POSTCARD HISTORY SERIES

Lake Boon

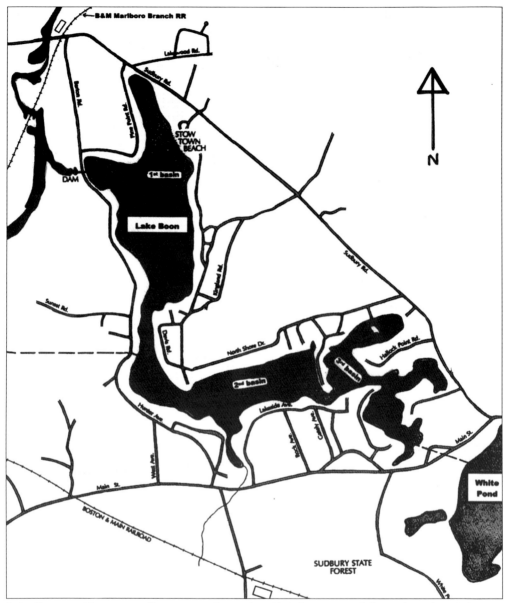

Lake Boon and its surrounding area are located at 42.4 degrees north latitude and 71.5 degrees west longitude.

POSTCARD HISTORY SERIES

Lake Boon

Lewis Halprin and Allan Kattelle

Copyright © 2005 by Lewis Halprin and Allan Kattelle
ISBN 0-7385-3758-6

Published by Arcadia Publishing
Charleston SC, Chicago IL, Portsmouth NH, San Francisco CA

Printed in Great Britain

Library of Congress Catalog Card Number: 2004115819

For all general information contact Arcadia Publishing at:
Telephone 843-853-2070
Fax 843-853-0044
E-mail sales@arcadiapublishing.com
For customer service and orders:
Toll-Free 1-888-313-2665

Visit us on the Internet at http://www.arcadiapublishing.com

On the front cover: The *Princess*, used to transport lake residents around Lake Boon during the summer, is shown bringing a number of passengers to attend a party at the Twilight Club, one of several clubs around the lake. Only men could be members, but there were many parties and other events to which young ladies were enthusiastically invited.

On the back cover: A car traverses Barton Road as it passes over the Lake Boon dam, located in the northwest portion of the lake where it empties into Bailey's Brook. Boon Hill is in the background, as are several cottages along Pine Point Road.

CONTENTS

Acknowledgments		6
Introduction		7
1.	Early History of Lake Boon	9
2.	Bolam's Home Café, Hanson's Beach, and Lake Boon Landing	21
3.	Boon Hill and Pine Point Road	31
4.	The Dam and Barton Road	49
5.	Second and Third Basins	67
6.	The Bluffs	85
7.	Summer Recreation	99
8.	Winter Recreation	115

Acknowledgments

Fortunately, in the early 1900s, at a time when the use of postcards was very common, there was also a thriving and active summer community around Lake Boon. This community often used postcards, which displayed pictures of the lake, to correspond with family and friends. The community also included many photographers, who found the area scenery and activity worthy of the subject of many photographs, many of which ended up as postcards. In particular, there was a Marlborough photographer, Alexander Berry, whose large four-by-six plate-glass camera was responsible for many of the postcards available today.

Today, many people who live in the area make it a point to collect as many Lake Boon postcards as they can find, and they have been very generous in sharing them with us. Many of the images in this book have a courtesy line citing the owner of the postcard or picture. The authors wish to thank the following people and organizations for sharing their postcards: Muriel Batsford, granddaughter of Prof. George Barton (founder of the Lake Boon Association); Paul Boothroyd of Maynard, curator of the Maynard Historical Society; Ralph Case of Maynard, who spent summers at Lake Boon as a child; Robert Collings, a resident of the Lake Boon area and founder of the Collings Foundation; Richard Conard of Wayland, owner of a large collection of glass photographic slides taken by Marlboro photographer Alexander Berry between 1890 and 1930; the Hudson Historical Society (HHS); Lewis Halprin, a Lake Boon resident; Alan Kattelle, a Lake Boon resident, Lake Boon historian, and former Lake Boon commissioner; the Maynard Historical Society (MHS); the Parker family of Hudson, summer Lake Boon residents; and Neal Phalan, a Lake Boon resident.

INTRODUCTION

Lake Boon, an L-shaped lake located in the towns of Stow and Hudson, was created by the movement of glaciers thousands of years ago. It was used as a source of water to augment the flow of the Assabet River, which provided waterpower for several mills downstream. After electricity replaced waterpower for the mills, the level of the lake remained constant and Lake Boon became a very attractive recreational area. Those living in the nearby towns quickly became aware of this budding recreational area, as did those living in Greater Boston, thanks to the fact that two railroad lines ran nearby the lake.

The interest in lakeside property started small with just a few sportsmen asking the farmers who owned land around the lake if they could erect cabins for the summer. These farmers, sensing more growth, began building cabins to rent to summer visitors. As the years went by, the number of people visiting the lake increased and cabins grew to more substantial cottages. By 1910, Lake Boon had become a hopping place.

Fortunately, the beauty of the lake area also attracted many photographers, and a substantial collection of large glass-plate photographs was created. Many of these photographs became postcards, which people dispatched to friends and relatives. These postcards, using words such as "wish you were here," described the wonderful times to be had at the lake. Many of these postcards are featured in this book.

Postcards have been in use since the Chicago Exposition of 1893, when illustrations on government-printed postal cards cost 1¢ each with a stamp already printed on the card. Writing was not permitted on the address side of the cards, so any messages had to be squeezed into the margins around the picture. By 1898, private printers were granted permission to print and sell postcards, and a 1¢ adhesive stamp was produced to put on these postcards. Writing was still not permitted on the address side. Several of the postcards in this book show a short message written around the picture's border.

It took until 1901 before the back of the postcard was permitted to be divided with the address on the right side and the message on the left side. In 1907, most postcards were printed in Germany because of their superior lithographic skills, but by 1915, postcards were printed in the United States on linenlike paper. Some were hand colored and usually had a white border around the picture. By 1930, improved printing processes allowed for full color postcards, and they were widely used as souvenirs of popular places and as a record of important events.

Most of the postcards shown in this book are from around the 1920s, and many were made

from high-quality photographs taken by Alexander Berry, from the nearby town of Marlborough, with a large-view camera that used four-by-six inch glass plates. Most of Berry's postcards have a distinctive *B* printed on them. Many of the postcards produced around this time were very personal, showing family groups or cottages. Any photographer could inexpensively print a family picture on special postcard photographic stock and mail them to other family members. These were always printed in black and white and probably never sold to the general public.

Lake Boon is a pictorial history of the lake and presents a collection of over 200 postcards and related images that show what photographers determined was beautiful around the lake. Like any good collection of postcards, these postcards are organized by location and activity. The first chapter provides a history of how the lake was formed by both nature and man, as well as some history of the ways in which people got to and around the lake using trains, boats, and streetcars. The next five chapters take the reader around the lake, each chapter starting with a map to show where various cottages and other lake features shown in that chapter are located. The final two chapters show the fun people had at the lake in both the summer and winter.

The stack of Lake Boon postcards that make up this book were gathered from a lot of people. Many of the postcards were found at antique stores or shows, some of the cards being over 100 years old. A few have been handled a lot and show their wear through fuzzy edges or faded ink. Many of the cards are similar to each other, sometimes created from the same glass-plate negative, but none are identical.

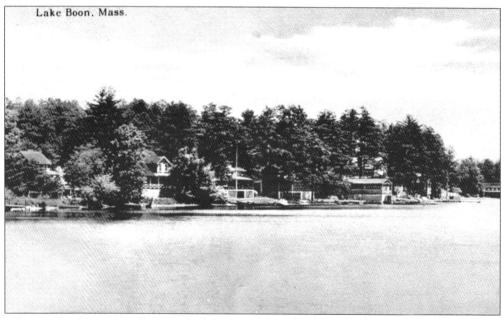

What used to be an unbroken stand of pine trees around Lake Boon is now scattered with over 300 cottages of every description and size sharing a common resource, the lake that is in the backyard of them all. (Parker family.)

One

EARLY HISTORY OF LAKE BOON

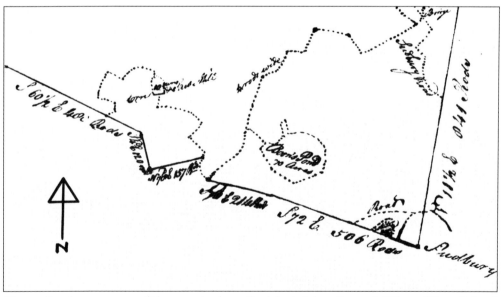

The earliest known map of the area to show the lake is Jabez Brown's "Plan of Stow," dated 1794. At that time, the lake was one simple basin called Boon's Pond that covered 70 acres. The pond received its inflow primarily from underground springs and partially by Ram's Horn Brook. This brook flowed through a meadow, Ram's Horn Meadow, which extended to the southeast of the pond for several miles. The name Ram's Horn Meadow appears on early maps and is mentioned in early property deeds of the area.

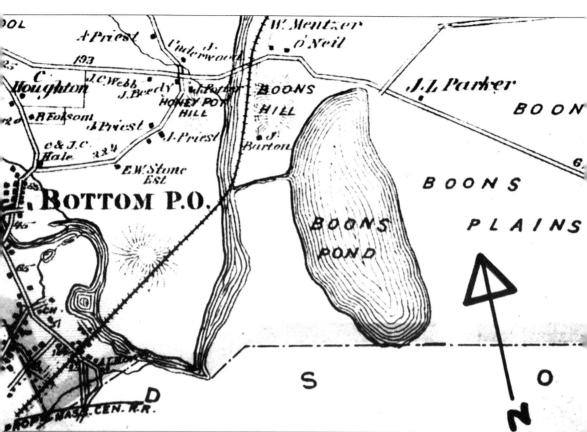

In 1845, Amory Maynard, proprietor of the mills in the town bearing his name, purchased the right to build a dam where the outflow of the lake flowed into the Assabet River through a small stream called Bailey's Brook. The chief purpose of this dam was to raise the level of the lake. This map, from *Beer's Atlas of Middlesex County* (1875), shows Lake Boon, still called Boon's Pond, after the first dam was built causing the lake to increase in size, though not to the size of today's multi-basin lake.

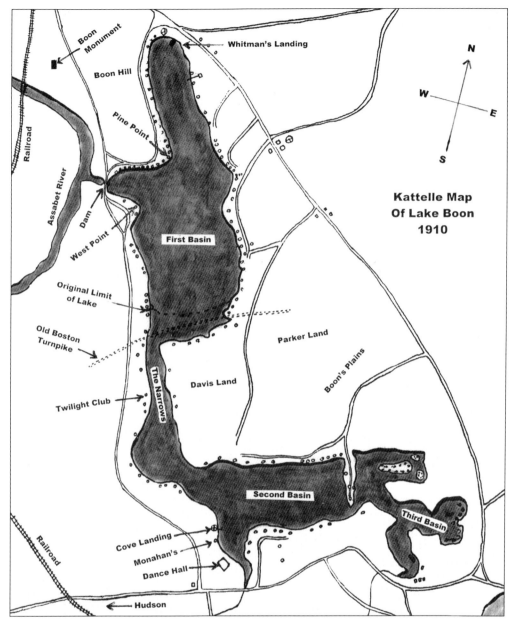

In the late 1800s, the Maynard woolen mill complex replaced the low dam at the outlet of Boon's Pond with a much higher one in order to capture more water for use when the Assabet River was running low. This greatly increased the size of the pond, now called Lake Boon, into three distinct basins.

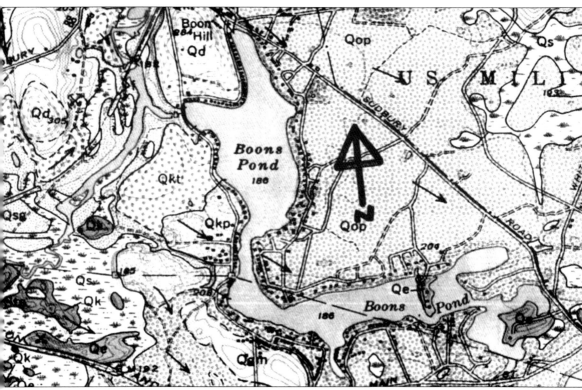

Lake Boon is an L-shaped body of water covering some 165 acres. The largest basin, known as the first basin, covers approximately 100 acres, with several smaller basins accounting for the other 65 acres. According to this 1948 U.S. Geological Survey map, Lake Boon sits in a terrain exhibiting many of the land features left by the retreating glaciers some 15,000 years ago. These include drumlins (Qd), kame terraces (Qkt), kame plains (Qkp), ground morraines (Qgm), ice-channel fillings (Qe), and outwash plains (Qop).

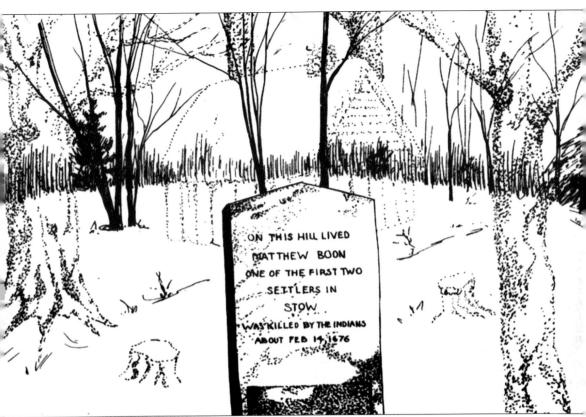

The lake, originally named Boon's Pond, got its name from its earliest settler, Matthew Boon. Boon came to this area from Charlestown in about 1660, looking for farm land. He evidently liked the area located near a river and small pond. One historian, Ethel B. Childs, states that Boon purchased a large tract of land surrounding the pond from the natives for one jackknife. Boon and his friend, Thomas Plympton, were killed in a conflict between settlers and natives in February 1676.

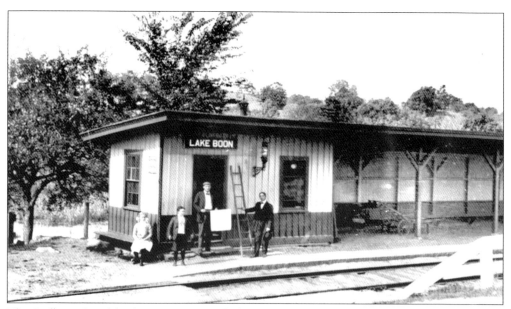

The Sudbury Road bridge was a particularly dangerous crossing, as vehicles going north on Sudbury Road could not see trains approaching the crossing from either direction. When it was realized that as many as 40 trains a day traveled this route, the railroad employed a crossing guard. The crossing guard's duty was to flag down the train if there were any passengers at the station that wanted to board and to prevent any auto traffic from crossing the rails. The guard was paid $1 per day. (Conard.)

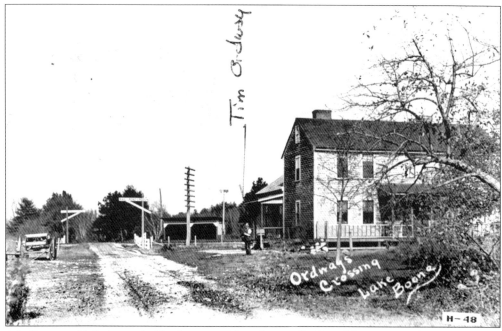

Lake Boon could also be reached by the central Massachusetts division of the Boston and Maine Railroad at a stop called Ordway. The Ordway railroad station lies less than one half of a mile down Parmenter Road, south of the lake. Here we see Tim Ordway standing in front of his house. (Halprin.)

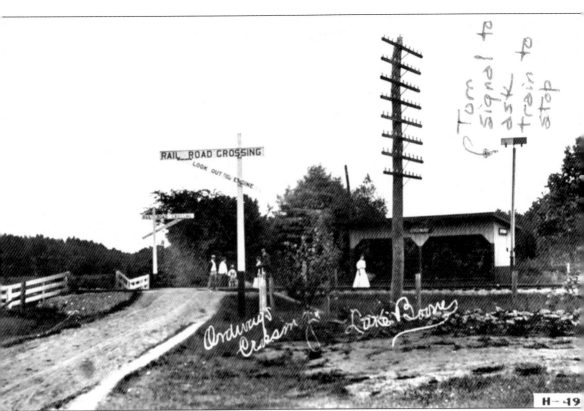

A group of people waits for the train to arrive at Ordway station. The signal on top of the pole (right) is turned sideways to let the train know that there are people at the station wanting to board. Note all the telephone wires on the telephone pole, which was a common site in those days before multi-wire telephone cable was used. Note also the handwritten "Lake Boone." This was a common misspelling, confusing the namesake Matthew Boon with the popular Daniel Boone. (Halprin.)

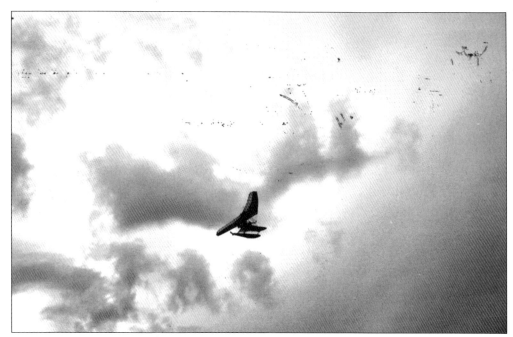

A most unusual way of coming to Lake Boon is to travel by ultralight aircraft. This craft has pontoons attached, which will let it land safely on water. (Parker.)

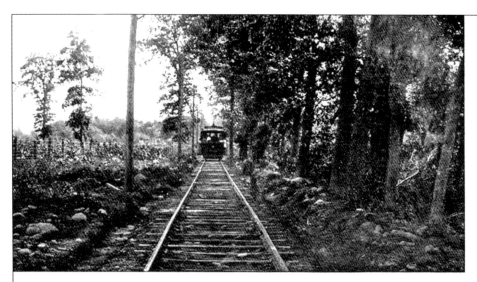

VIEW ALONG THE CONCORD, MAYNARD & HUDSON ST. RY. AT STOW

To get to the lake from Stow or Maynard, a traveler may have taken a streetcar on the Concord, Maynard and Hudson Street Railway, which began operation in 1901. If the weather was pleasant, they may have traveled in an open car. Near Lake Boon, the street railway (trolley) got off of Gleasondale Road and cut through a field in order to avoid several large hills. (Boothroyd.)

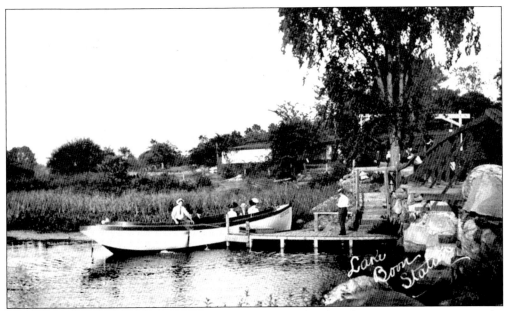

The *Queen*, a pretty motor launch that operated on weekends only to carry passengers on the Assabet River from Maynard to the lake, was owned and operated by Peter Wilcox and Fred Chandler from 1906 to 1914. This postcard shows three ways to reach the lake: the motor launch, the railroad shown in the background, and by automobile over the Sudbury Road bridge shown at the right. (Boothroyd.)

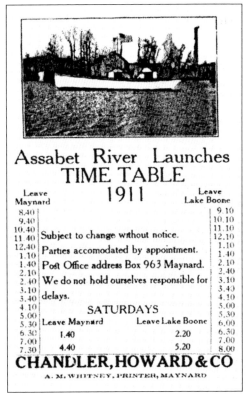

Shown here is an Assabet River boat timetable.

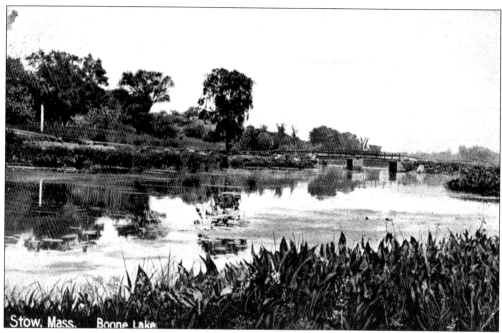

Shown in the distance is the Sudbury Road bridge over the Assabet River. The road was one of the principal ways that people from the north and west traveling by car, horse, or wagon would get to Lake Boon. (Batsford.)

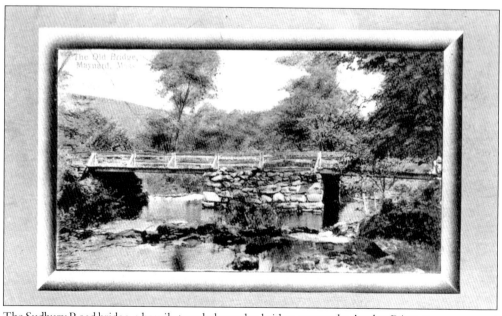

The Sudbury Road bridge, a heavily traveled wooden bridge, crosses the Assabet River at a narrow spot and is supported by several foundations made up of mostly large stones. This was also the location of the Lake Boon stop on the Boston and Maine Railroad and the *Queen* motor launch. (Boothroyd.)

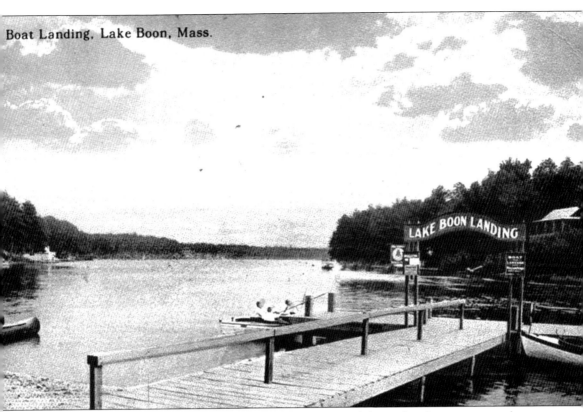

The proximity to both the railroad station and Sudbury Road, located at the extreme northern end of Lake Boon, made Lake Boon Landing the most logical place for docking the passenger boat *Cleo* and its successor, the *Princess*. (Phalan.)

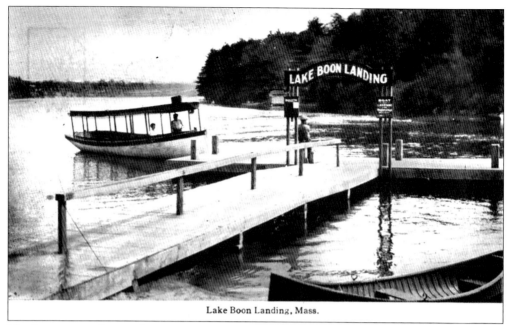

Lake Boon Landing, Mass.

The *Princess*, a 35-foot gasoline-driven motor launch, was owned by Linus E. Canning and operated by Larry Kattelle, a young man whose family summered on the lake at a nearby cottage. Larry took over operation of the *Princess* while on summer vacation from college. (Parker family.)

LAKE BOON TIME TABLE — In effect JUNE 23, 1913.

WEEK DAYS

Landings		A. M.								
Lake Boon	Leave	*7.15	*8.05	*9.10	9.45	10.20	*11.10	11.45	*12.45	*2.00
Cove		†7.30	8.30	9.20	9.55	10.30	11.20	†12.00	†1.00	2.25
Lake Boon	Arrive	*7.50	*8.55	9.35	10.15	*10.50	11.40	*12.25	*1.40	2.35

SUNDAYS

Landings		A. M.								P. M.
Lake Boon	Leave	9.25	*10.40	11.40	*12.25	1.35	2.05	2.35	3.05	*3.35
Cove		9.40	10.50	11.50	12.35	1.45	2.15	†2.45	3.15	3.45
Lake Boon	Arrive	*10.10	11.15	*12.10	1.00	2.05	2.35	*3.05	3.35	*4.10

FOR EVENING DANCES

Landings		P. M.					
Lake Boon	Leave	*7.50	*8.30	9.35	
Twilight Club		7.57	8.37	9.42	10.35	†11.30	
Canning's Grove		8.02	9.15	9.50	10.40	†11.35	
Twilight Club		8.07	9.20	9.55	10.50	*11.45	
Lake Boon	Arrive	8.20	9.27	*11.55	

TO SIGNAL BOAT stand on wharf
*Connects with trains at Lake Boon
†Connects with trains at Ordway,
Figures in BLACK FACE TYPE made as traffic demands.
Boat connects with late trains on order
For rates and boat service for picnics,
Kattelle, Leasee.

Until Larry Kattelle took over operation of the *Princess*, it had operated on a rather hit or miss schedule. If a rider was down on their dock when the *Princess* came along, all was well and good, and they clambered aboard. But if the *Princess* left Lake Boon Landing later or earlier than usual, a rider had to find some other means of getting to Ordway station. When Larry took over he recognized the need for a regular schedule and had one printed up.

Two

Bolam's Home Café, Hanson's Beach, and Lake Boon Landing

Shown here is a map of the northernmost tip of Lake Boon. This area was known as Lake Boon Landing (sometimes called Boon's Landing, Whitman's Landing, or even inaccurately, Cove Landing) located at the intersection of Sudbury Road and Pine Point Road. Travelers arriving to the lake by train would walk a short distance to the Lake Boon Landing dock to board the *Princess*, which would take them to their destination cottage or recreational area.

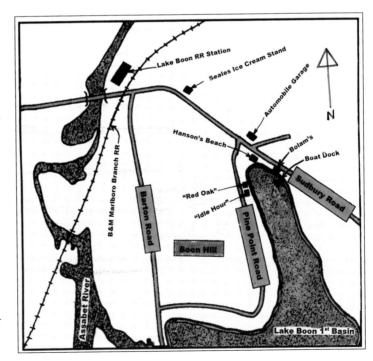

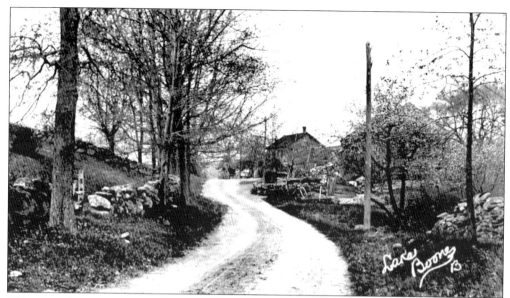

This view shows Sudbury Road as it comes from the bridge over the Assabet River, past the Bolam house, with Boon Hill on the left. This short stretch was used by those arriving to the lake by railroad from Whitman's (Lake Boon) Crossing, from the *Queen* coming from Maynard, by the Concord, Maynard and Hudson Street Railway, or by horse and buggy or automobile from Stow, Hudson, or other western communities. At the bottom of this hill is Pine Point Road and Bolam's Home Café. (Batsford.)

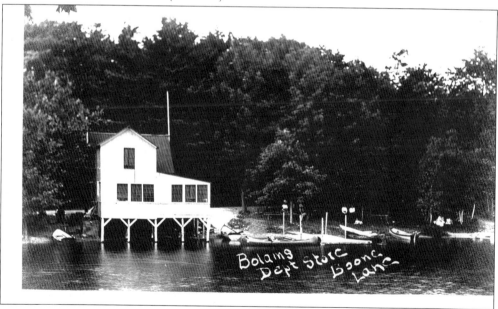

The earliest pictures of this area show a single building, Bolam's Home Café. It was originally a summer home built in 1897 by Mr. and Mrs. George Bolam and was later called Bolam's Home Café because the Bolam's were members of a fraternal organization called the Home Circle. The little Bolam's Home Café later grew into a small department store, which took advantage of the resident traffic that used the substantial boat dock that was built next to the store. This dock was used by both the *Cleo* and the *Princess* passenger boats. (Boothroyd.)

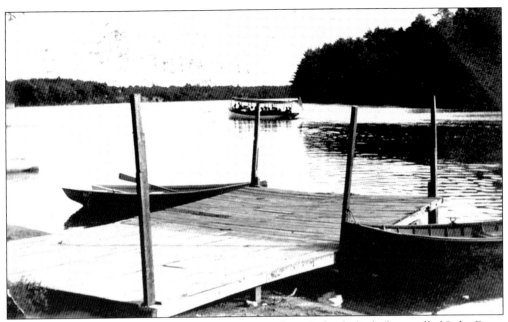

Many people took advantage of the *Princess* leaving from Bolam's dock (later called Lake Boon Landing) to take a pleasant trip around the lake or to take them to a dock near their cottage. (Parker family.)

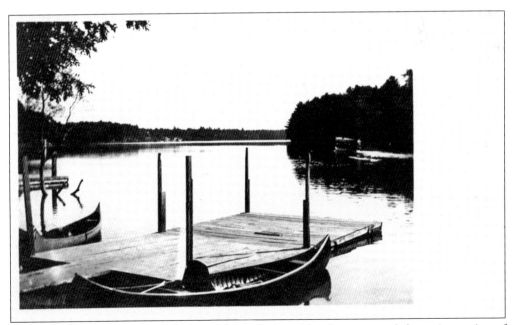

Shown here is the *Princess* as it leaves Bolam's dock and heads out toward the main portion of the first basin. (Batsford.)

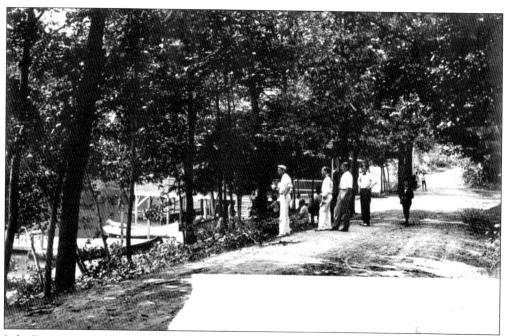

Lake Boon summer residents walk down Sudbury Road to Lake Boon Landing, next to Bolam's, to board the *Princess* that will take them to their cottages. (Halprin.)

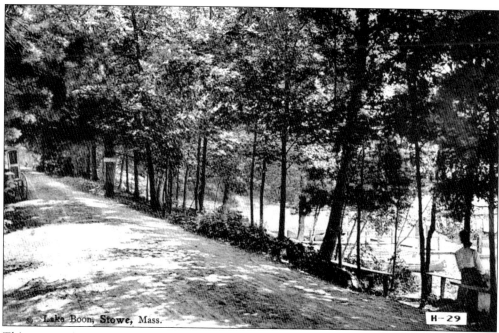

This woman is waiting for the *Princess* at Lake Boon Landing on Sudbury Road. (Halprin.)

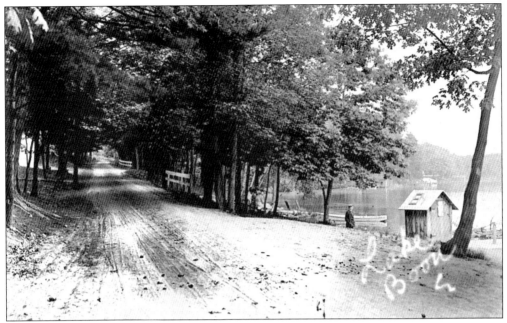
A man waits for the boat at Lake Boon Landing on Sudbury Road. (Batsford.)

On Sudbury Road, across from Bolam's store, is the Mitchell home hiding within a thicket of shade trees. (Batsford.)

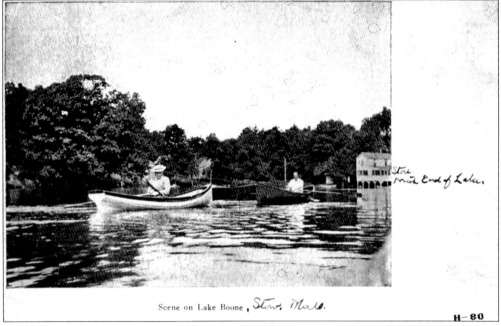

The dock next to Bolam's was used by more than the *Princess*. Here, two boaters provide their own power to get to their destination. (Halprin.)

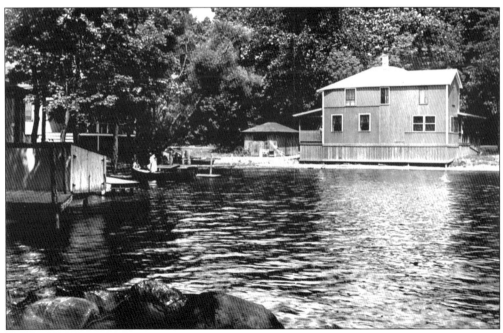

A much larger building and store replaced Bolam's Home Café when it was torn down. The small shed on the side of the house may have been for swimmers. Red Oak Cottage, with its small boat house, is seen on the left. (Batsford.)

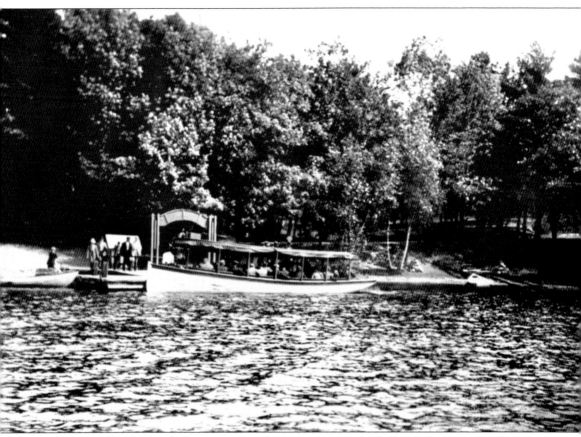

The *Princess*, with a full load of passengers, makes a stop at its main dock at Lake Boon Landing. Sunday afternoon was always the busiest time of all. In Lakeside, on the south shore or Hudson side of the second basin, there was a baseball diamond. The games played there drew large crowds from Marlborough, Hudson, and Maynard. When the ball game was over, there was a mad rush to get a seat on the *Princess*. All seats were filled immediately and standees filled the deck space for a total of over 100 riders. The operator had the job of working his way through the crowd to collect the dimes for the trip down the lake. (Conard.)

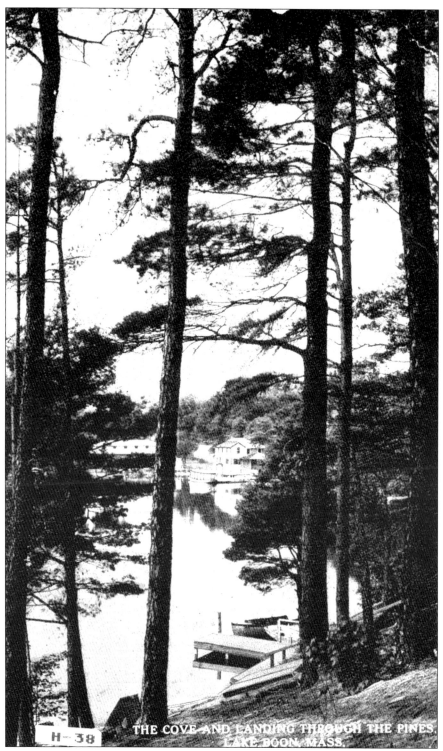

This is a distant view of Lake Boon Landing (center), with the *Princess* docked next to Bolam's Home Café. (Halprin.)

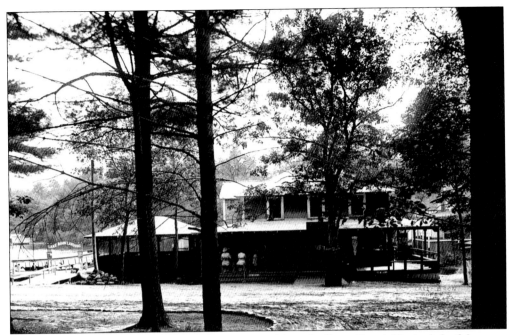

Shown here is an expanded Bolam's store as viewed from Sudbury Road. To the left of the store is a screened porch, perhaps for those visiting the café. To the left of the porch is the arch over the end of the Lake Boon Landing dock. (Phalan.)

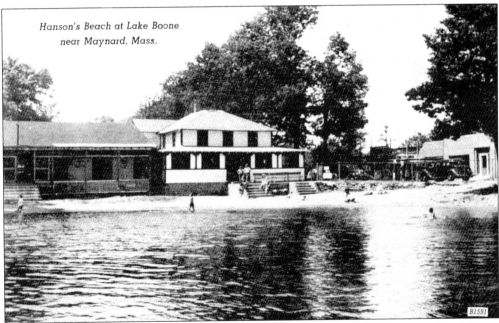

Although no proof can be found, it appears that Bolam's store was replaced by a public beach house complete with a large bathhouse and sandy swimming area. It was located on Sudbury Road (slightly farther north than where Bolam's was) next to Pine Point Road. Across the street on Sudbury Road was the Lake Boon gas station and auto repair shop (right). This whole area was called Hanson's Beach and later Rooney's Beach when ownership changed hands. (Boothroyd.)

Swimmers are shown here at Hanson's Beach. Boon Hill is in the background with the area called Pine Point on the far left. (Conard.)

Hanson's Beach, at the north end of Lake Boon, was sold to the Rooney family and known for many years as Rooney's Beach. The beach house, no longer standing, is now a private residence. (Phalan.)

Three

Boon Hill and Pine Point Road

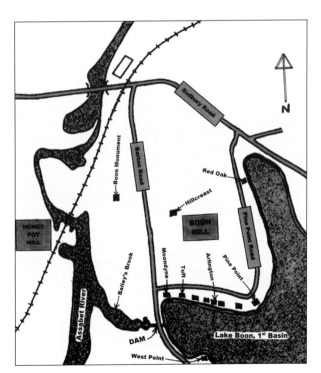

This is a map of Pine Point Road and a section of Barton Road. These two roads, along with Sudbury Road, circle Boon Hill located at the northern end of Lake Boon.

At the intersection of Sudbury Road and Pine Point Road is the Willow cottage and a few boathouses. Just visible on the left is Red Oak cottage. (Phalan.)

Red Oak is seen here (left of center) on the lakeshore. Behind it can be seen a portion of Boon Hill. At one time, there were several tiny "honeymoon" cottages on the bare portion of the hill. It is speculated that Hanson's Beach constructed these miniature cabins, with room for a bed and a very small kitchen, to rent to people for short periods of time. These were similar to today's motels. (Boothroyd.)

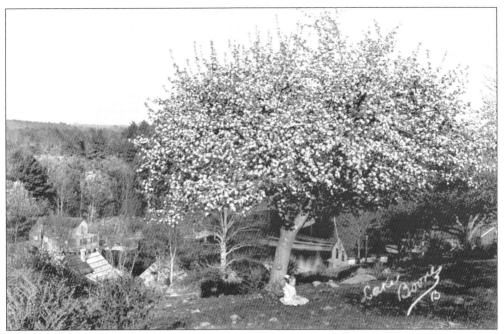

From the top of Boon Hill on Pine Point Road, Bolam's store (left) is visible with its beach and boat dock. The small girl resting under the tree is believed to be the daughter of Alexander Berry of Marlborough, the photographer of many postcard pictures. (Batsford.)

The Berry girl looks down the hill on Pine Point Road near Hanson's Beach. (Batsford.)

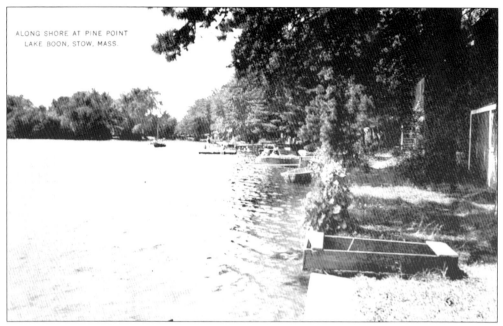

This postcard is a lakeside view from Pine Point cottage looking west toward the dam. (Parker family.)

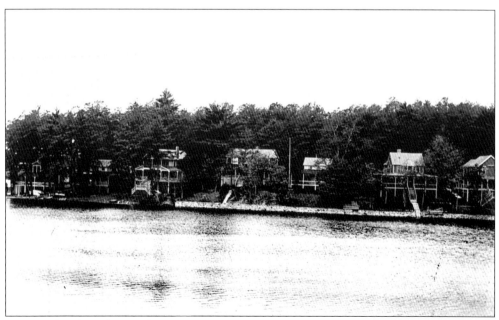

Hugging the relatively steep slope of Pine Point Road as the road traverses away from Hanson's Beach are many cottages with long stairs leading down from their porches to the water's edge. (Batsford.)

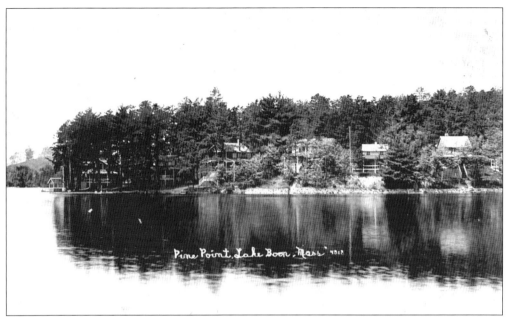
Shown here, at the southern end of Boon Hill, is the area called Pine Point. (Batsford.)

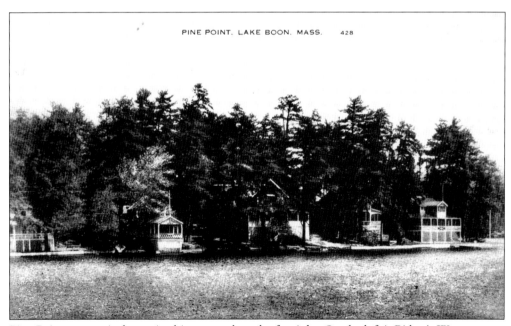
Pine Point cottage is shown in this postcard on the far right. On the left is Bide-A-Wee cottage, which has a boat house attached to it with a screened porch on top. (Halprin.)

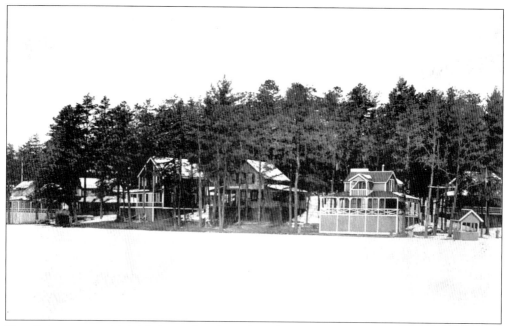

Pine Point cottage (right) is located at the point where Pine Point Road makes a sharp turn to the west. At the water's edge is a distinctive gazebo where the cottage owners can enjoy a waterfront seat. (Batsford.)

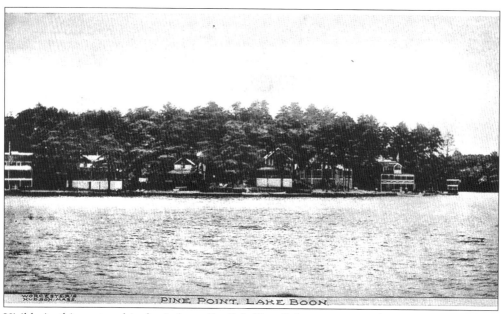

Visible in this postcard is the Jackson family's Pine Point cottage (right), and the Arlington cottage (left). (Halprin.)

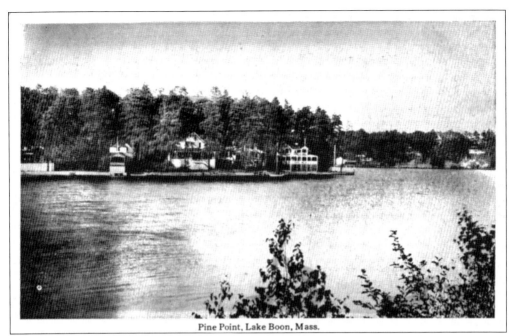

Pine Point, Lake Boon, Mass.

These are views from across the lake of the cottages around Pine Point. (Batsford.)

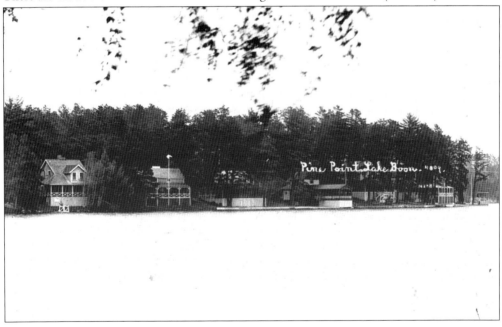

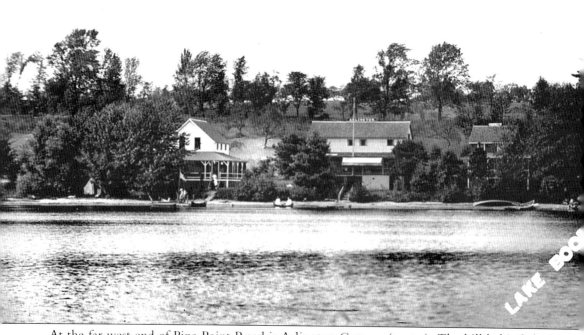

At the far west end of Pine Point Road is Arlington Cottage (center). The hill behind the cottages, Boon Hill, has only a small number of pine trees at this location. The area used to contain a corn field and pasture. (Batsford.)

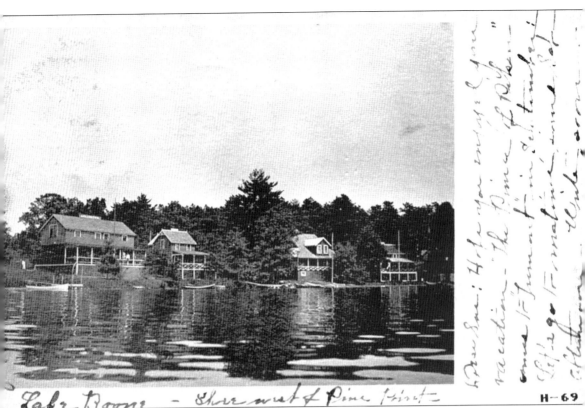

This postcard shows several cottages on the lake, as they looked around 1900. Arlington cottage is on the left and the cottage just to its right is Radcliff. To the right of the large pine tree in the center of the postcard is the Deborah cottage. Prior to 1901, only the postal address was permitted on the backside of postcards requiring any personal message to be squeezed onto the picture side of the card as seen on this postcard. (Halprin.)

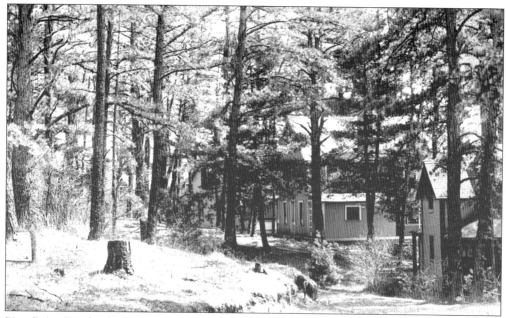
Pine Point Road, a little country dirt road, makes a sharp turn about where Pine Point cottage is located. (Batsford.)

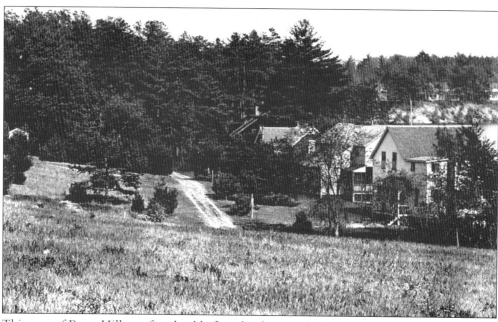
This part of Boon Hill was farmland before the dam was built, causing part of the land to be underwater. At the time this picture was taken, one side of Pine Point Road was solid cottages while the other side was often used for growing farm products. (Halprin.)

Lake Boon Road, Mass. H-22

Pine Point Road begins at Sudbury Road and immediately climbs Boon Hill. About halfway to the other end of Pine Point Road at Barton Road, the road levels off to a beautiful drive through the pine trees. Cottages are nestled on the lakeside and Boon Hill is on the other side of the road. (Halprin.)

This is how Pine Point Road used to look in its early days. The postcard shows the road, which was not much more than a path at the time, somewhere around where Pine Point cottage is located. (Batsford.)

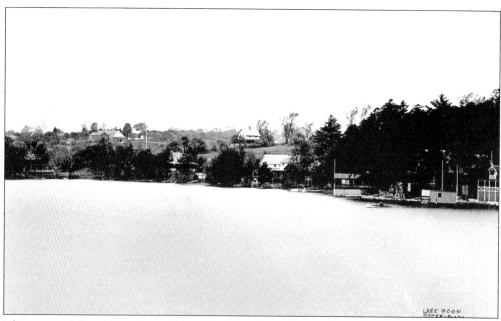

This postcard shows how the section of the lake situated around the dam looked in 1907. To the left is the dam, on the right is Boon Hill, and in the distance is Honey Pot Hill. (Batsford.)

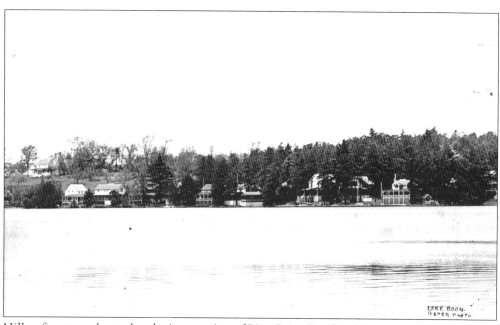

Hillcroft cottage, located at the intersection of Pine Point Road and Barton Road, can be seen on the far left of this postcard, up on the slope of Boon Hill. (Batsford.)

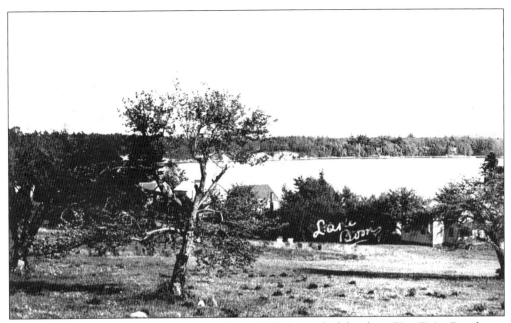
This bird's-eye view from near the top of Boon Hill shows the lake along Pine Point Road near Barton Road. The few trees that remain are from an old orchard. (Phalan.)

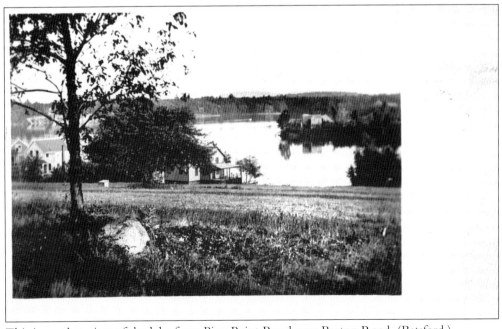
This is another view of the lake from Pine Point Road near Barton Road. (Batsford.)

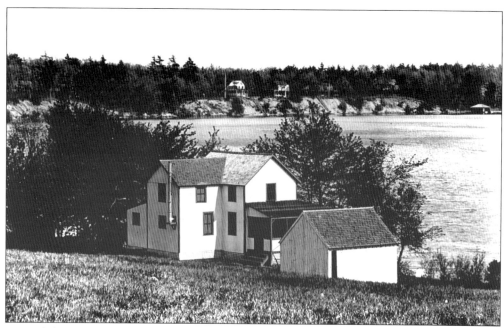

Toward the west end of Pine Point Road is a large cottage and its garage. The lake is on one side and an open field, formerly a corn field, is on the other. Notice in the distance how bare the bluffs are on the east side of the lake. Part of that area now includes a recreational field and a swimming beach for Stow residents. (Halprin.)

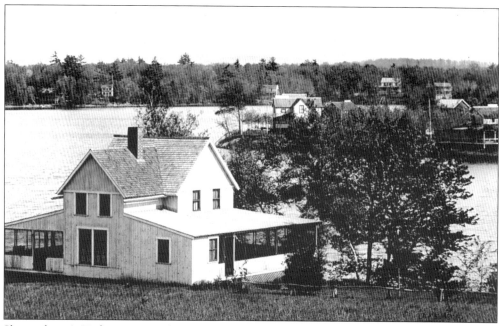

Shown here is Tufts cottage, which has been enlarged several times by adding and enclosing several porches. (Halprin.)

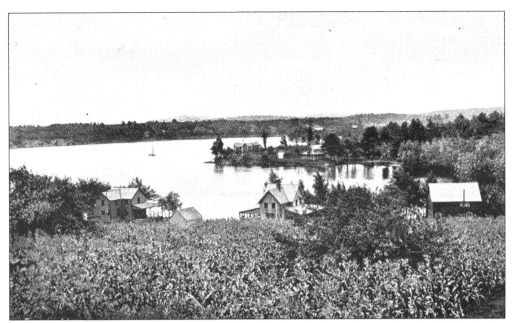

At one time, the land around the corner of Pine Point Road and Barton Road was all part of a large farm. As homes were built for summer people, these farm lands were replaced by cottages. Here we still see a field of corn occupying this corner of Boon Hill. (Phalan.)

This intersection of Barton Road and Pine Point Road is viewed from the bottom of Boon Hill. In the early days, all the roads around the lake were unpaved. (Halprin.)

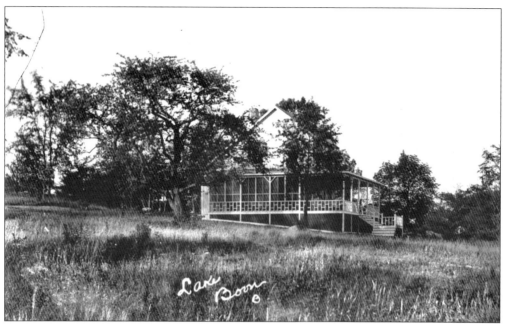

Hillcroft cottage, located near the top of Boon Hill, is on Barton Road. The porch of this cottage provides a superb view of almost the entire first basin of the lake and was a favorite place for photographers to set up their equipment. Many postcards of the lake were made from photographs taken at this location. (Phalan.)

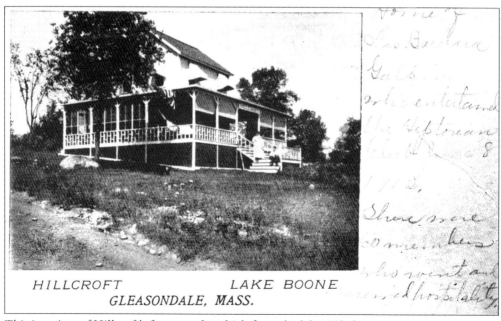

This is a view of Hillcroft's front porch, which faces the lake. (Phalan.)

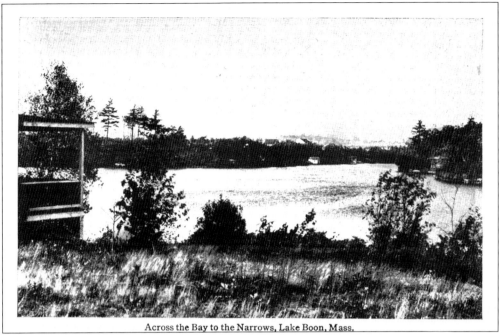

Across the Bay to the Narrows, Lake Boon, Mass.

This is the view from the lawn of Hillcroft cottage. Visible is almost the complete first basin of the lake, all the way down to the narrows. (Phalan.)

Lake Boon, Mass.

Typical of the many pictures of Lake Boon taken from the porch of Hillcroft cottage on Boon Hill is this scene showing a lone apple tree, cottages on Pine Point Road, and West Point cottage (center). (Parker family.)

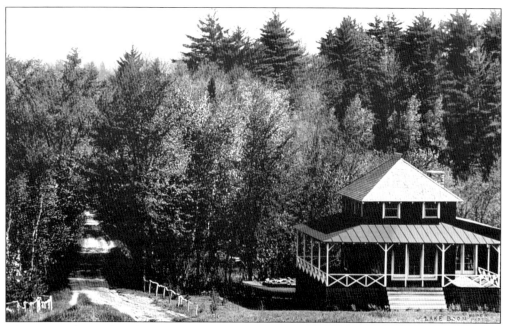
The cottage shown here has a great view of Lake Boon, the Assabet River, and Bailey's Brook, the stream that connects the lake to the river. (Halprin.)

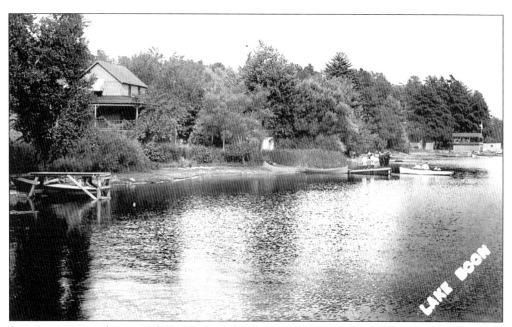
Seen here is an early view of the Pine Point Road area as seen from the causeway that leads to the dam. (Batsford.)

Four

THE DAM AND BARTON ROAD

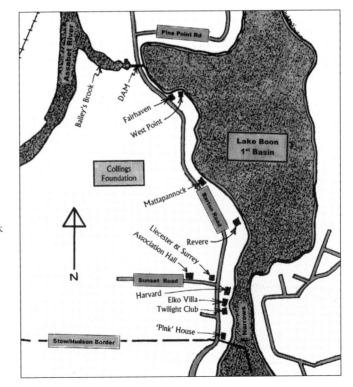

The dam across Bailey's Brook creates Lake Boon. Without the dam there would only be one small body of water and it would be called Boon's Pond. The road across the dam, Barton Road, joins the cottages around Boon Hill and Pine Point Road to the cottages around the second and third basins. (Halprin.)

The dam that holds the waters from Lake Boon from pouring into the Assabet River is located on Barton Road, past Pine Point Road. Barton Road continues across this earthen dam where the overflow waters from the lake drop through a spillway into Bailey's Brook, a short brook that connects the lake to the Assabet River. At one time, the road over the dam was lined with many white birch trees that leaned out over the lake as if trying to hold back the water. (Batsford.)

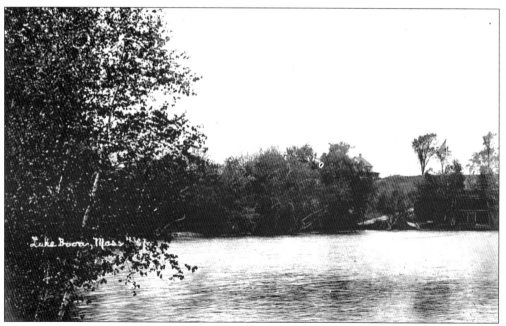

This postcard is a view from the birch trees that line the dam, looking toward Boon Hill. (Batsford.)

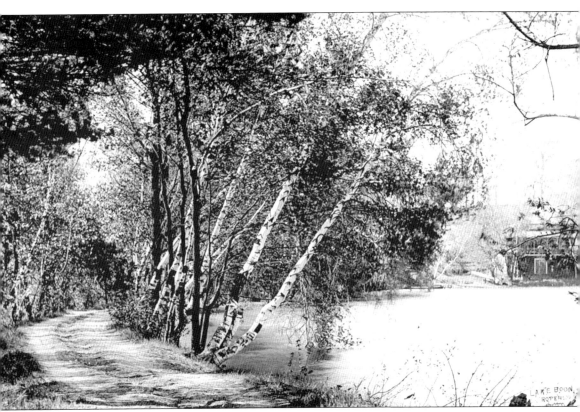
This close-up view of the dam shows Barton Road, which was unpaved at the time, and its distinctive white birch trees. (Phalan.)

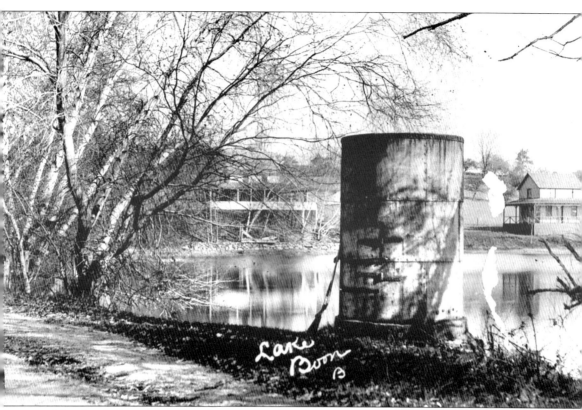

The dam is the only outflow from the mostly spring-fed lake. By removing or adding boards in the spillway, the lake level may be altered as needed. It was the practice to lower the level of the lake somewhat in the spring, enabling dock owners to repair any winter damage to their docks. The barrel shaped container shown in this postcard is thought to have contained tools to raise or lower the boards that determined the lake level. (Phalan.)

The Fairhaven cottage, located south of the dam area, is seen here. (Batsford.)

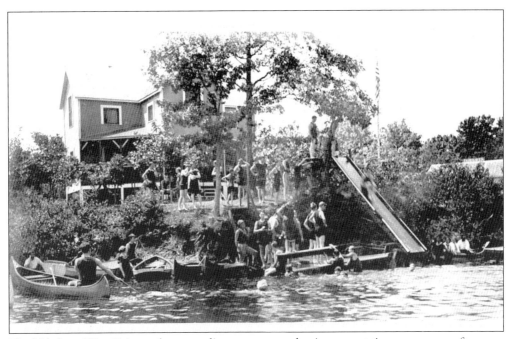
The kids from West Point and surrounding cottages are having a great time on a warm afternoon as they slide down a long homemade slide into the lake. (Batsford.)

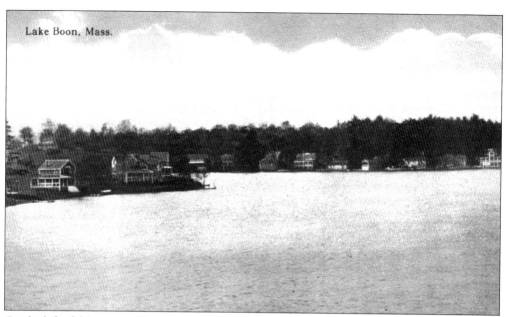

On the left of this postcard is West Point cottage and several of its neighbors. In the background, toward the right, are cottages on Pine Point Road. (Batsford.)

The cottages shown here are on the west side of Lake Boon's first basin and form the area called West Point. (Batsford.)

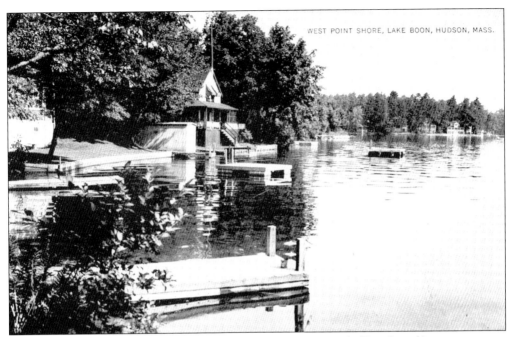

Shown here are several cottages and their docks on Barton Road. (Boothroyd.)

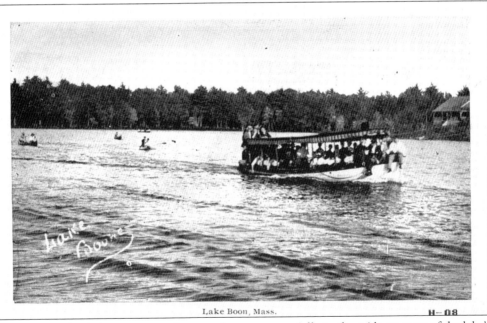

A nice sunny day brings out many boats and canoes, especially to the wide expanse of the lake's first basin. After an afternoon baseball game at Cannings Grove or near Lakeside Landing, there would often be a standing room only crowd on the *Princess* to take passengers back to Lake Boon Landing where they could get a train home. Here we see the west shore of the lake with Barton Road in the background. (Halprin.)

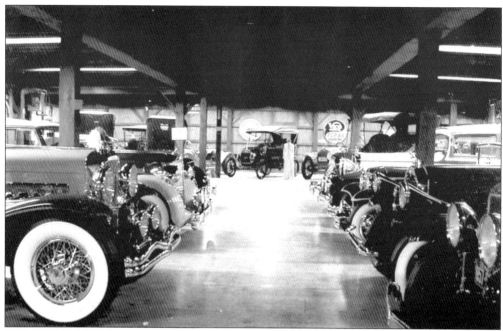

The Collings Foundation complex consists of two large barns and the modern residence of the Collings family. One of the barns holds the foundation's large collection of antique automobiles, a portion of which is shown here. (Collings.)

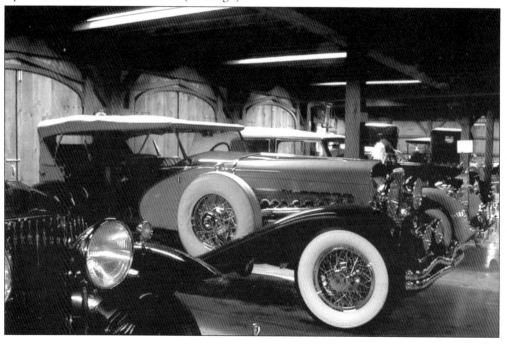

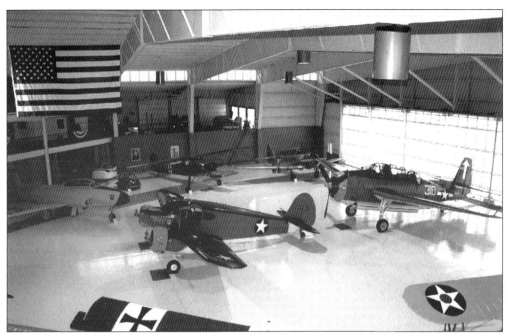

A second large structure that is part of the Collings Foundation is an airplane hangar full of antique airplanes, most of which are old military planes from World War I and II. (Collings.)

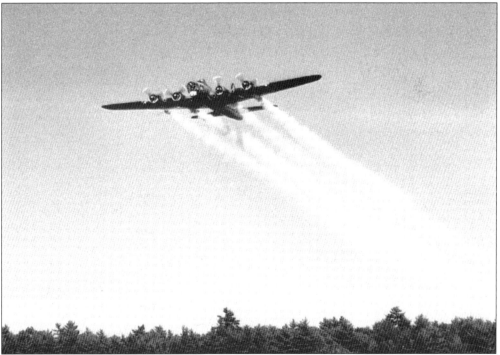

Flying in tribute to Robert Collings's birthday in 1998, is a giant B-17 from World War II. The Collings Foundation owns this B-17 as well as a flying B-24, which they exhibit all over the country and allow former U.S. Air Force men, who flew these planes during the war, to relive the experience by joining the crew on a flight. (Collings.)

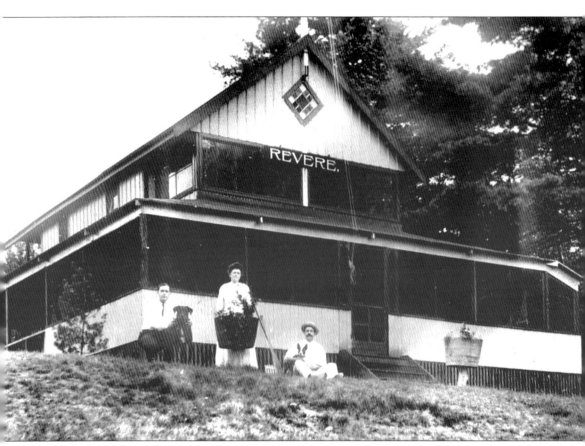
On the banks of the narrows is Revere cottage. Quite a few homeowners gave their cottages names and often put the name on a large sign that could be seen from the lake, as seen in this postcard. In the early days of the lake, there were no street addresses assigned to the cottages so most used cottage names to identify their place to visitors and passersby. (Conard.)

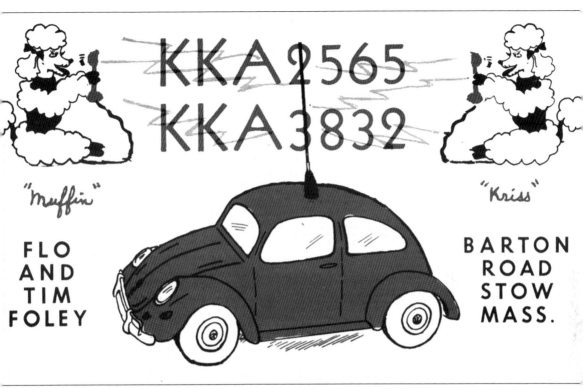

Flo and Tim Foley on Barton Road take their amateur radio license seriously and communicate from their cottage on the lake to people all over the world. (Boothroyd.)

Lake Boon, Mass.

At the base of the first and largest basin of Lake Boon, the waters narrow down into a channel called the narrows, which connects the first and second basins of the lake. Along this portion of the lake there are more elegant cottages and bachelor clubs. This view is from the second basin looking through the narrows toward the first basin. (Phalan.)

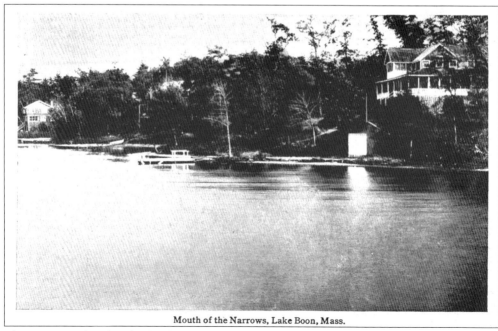

Mouth of the Narrows, Lake Boon, Mass.

The narrows is lined on both sides with cottages. All motorized boats are required to travel at a slow no wake pace and stay to the right while they are going through the narrows. (Phalan.)

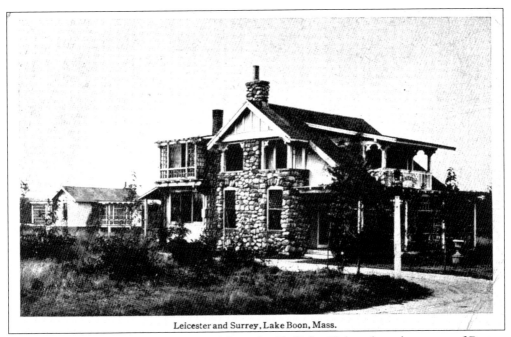

Just a short distance down Barton Road from the Twilight Club and on the corner of Barton Road and Sunset Road is Leicester and Surrey, a curious cottage with stonewalls. (Halprin.)

This postcard, dated 1912, shows an earlier version of the Leicester and Surrey cottage. (Boothroyd.)

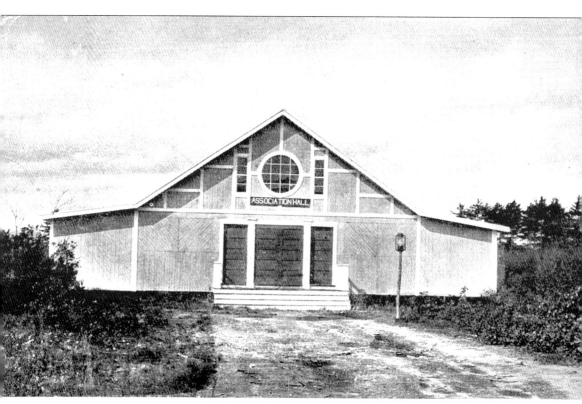

Association Hall, Lake Boon, Mass.

Just in back of Leicester and Surrey cottage on Sunset Road is Association Hall, built primarily for Sunday Catholic services, but often used for meetings of the Lake Boon Improvement Association and other groups around the lake. (Phalan.)

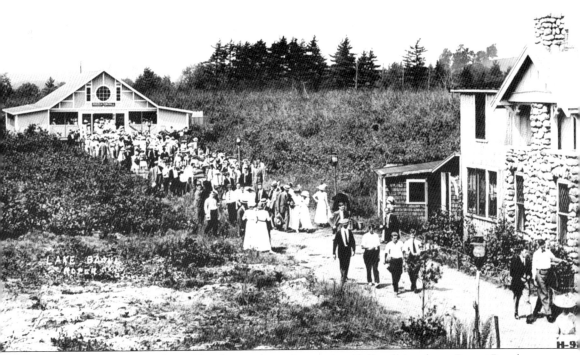

This postcard shows attendees of Sunday service at Association Hall walking down Sunset Road, over to Barton Road, and back to their cottages. The Leicester and Surrey cottage is shown on the right. (Halprin.)

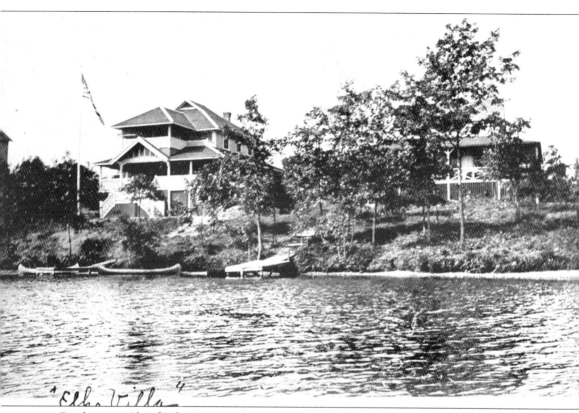
On the west side of Lake Boon at the narrows area on Barton Road are two elegant cottages, the Harvard (right) and the Elko Villa (left). (Phalan.)

This building, between Barton Road and the narrows section of the lake, may have once been a store as display shelves are visible through the windows. The building, found near the border of Stow and Hudson, was recently painted pink.

This postcard shows the border between Stow and Hudson where Barton Road changes to Hunter Avenue.

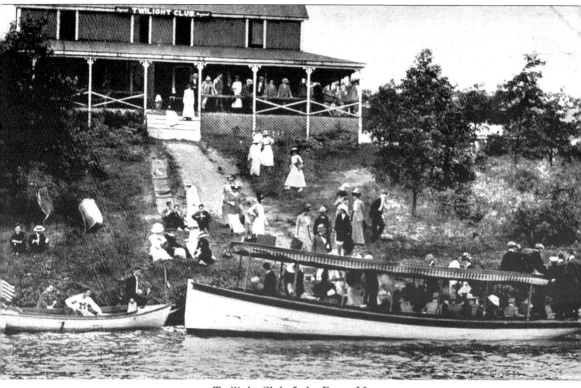

Twilight Club, Lake Boon, Mass.

The Twilight Club, located on Barton Road next to the Narrows section of Lake Boon, was one of several men-only clubs around the lake. Here, the passenger boat *Princess* is picking up several of the elegantly dressed people leaving an event that took place at the club. (Halprin.)

Five

SECOND AND THIRD BASINS

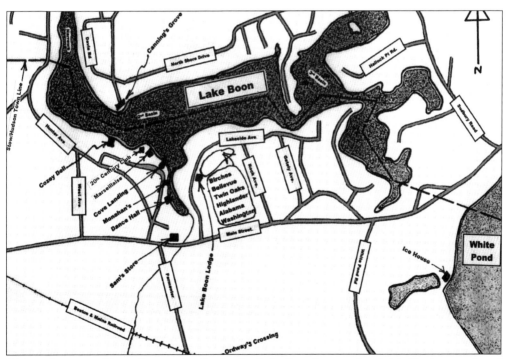

Although not as wide or deep as the first basin, Lake Boon's second and third basins are ringed by many cottages and points of interest including several stores, a dance hall, a very large ice house, a hotel, and railroad station. (Halprin.)

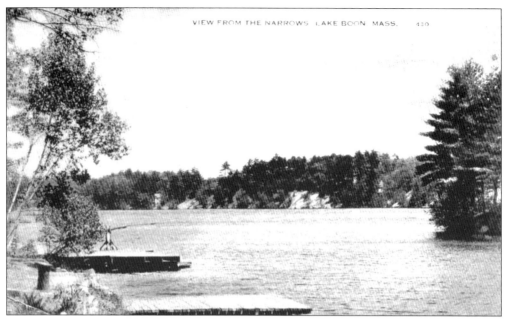

Crossing the town line from Stow to Hudson, Barton Road changes to Hunter Avenue, and the narrows open up into another wide expanse, the second basin. (Halprin.)

This view is from a boat at the entrance of the second basin of Lake Boon looking through the narrows to the first basin. Visible in the far distance is Boon Hill. (Batsford.)

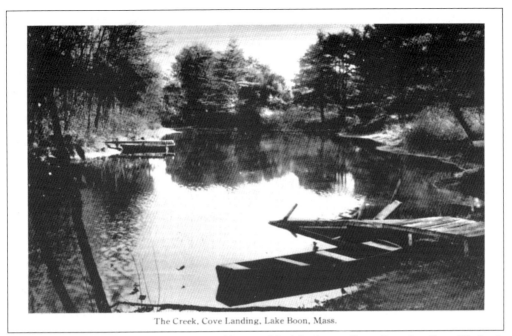

This view of the cove inlet from the second basin of the lake is seen from Cove Landing. (Phalan.)

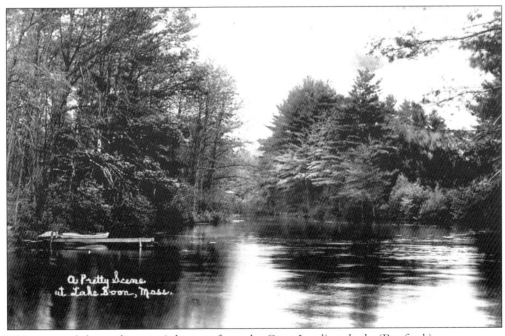

This postcard shows the cove inlet area from the Cove Landing dock. (Batsford.)

Cosey Dell cottage, located on Worcester Avenue near Hunter Avenue, has a grand view of the lake from its large porch. (HHS.)

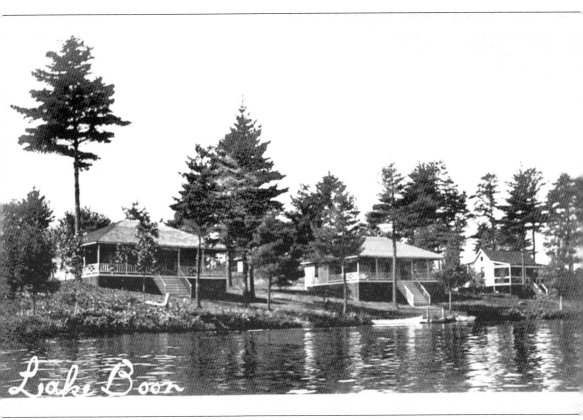

Cosey Dell cottage (right) is located on the southern side of the lake near the cove section of the second basin. All of the cottages in this postcard have distinctive staircases from their porches extending down toward the lake. (Phalan.)

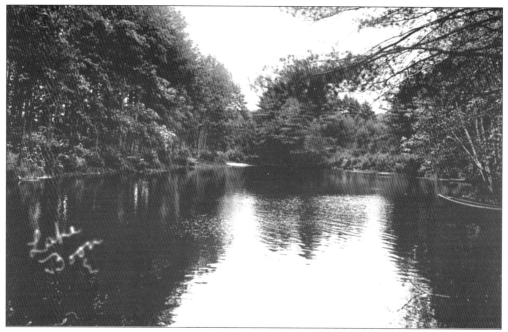
Another view from the Cove Landing dock shows the cove inlet area. (Batsford.)

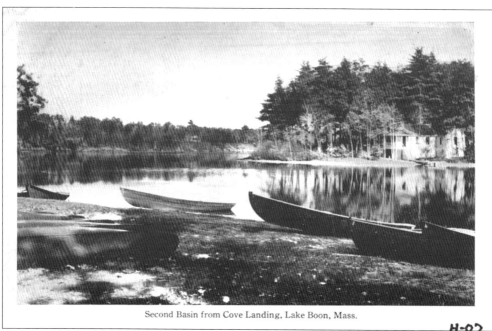
Shown here is the second basin of the lake from the relatively shallow cove inlet. (Halprin.)

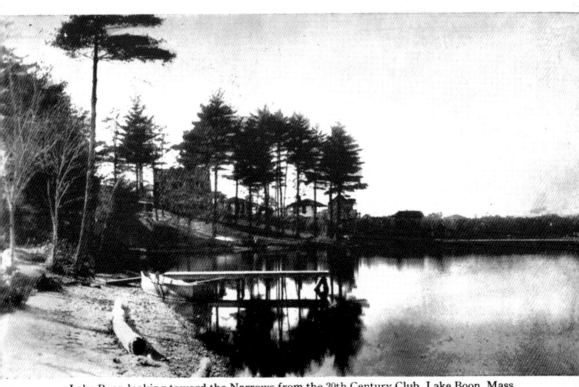
Lake Boon looking toward the Narrows from the 20th Century Club, Lake Boon, Mass.

This is a view of the narrows as seen from the dock in front of the 20th Century Club on the second basin of Lake Boon. (Phalan.)

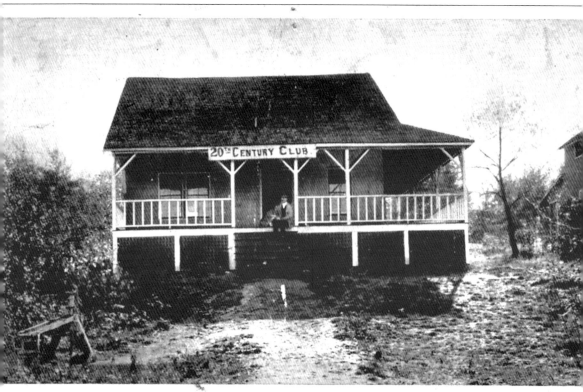

20th Century Club, Lake Boon, Mass.

The 20th Century Club was one of the many bachelor clubs on Lake Boon and was located just before Cove Landing. (MHS.)

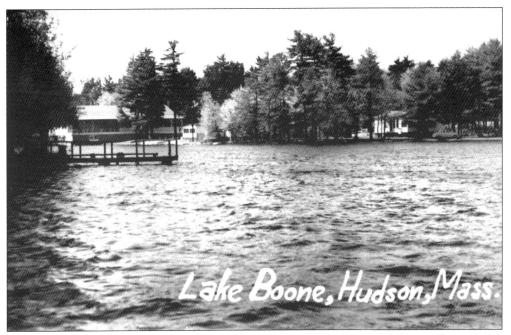

Looking back into the cove from the second basin of the lake, a large building can be seen that is probably the infamous Monahan's, a bar and belly dancing establishment frequently visited by the Hudson Police on official duty. (Phalan.)

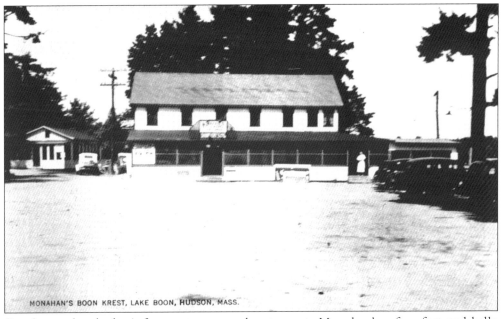

On the weekend, the infamous tavern and restaurant, Monahan's, often featured belly dancers. (Halprin.)

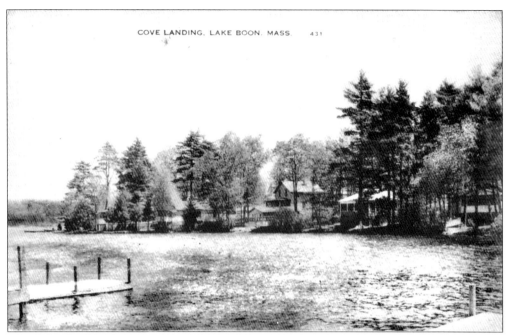

Outside of the cove area of the second basin is a group of cottages located along Lakeside Avenue. (Phalan.)

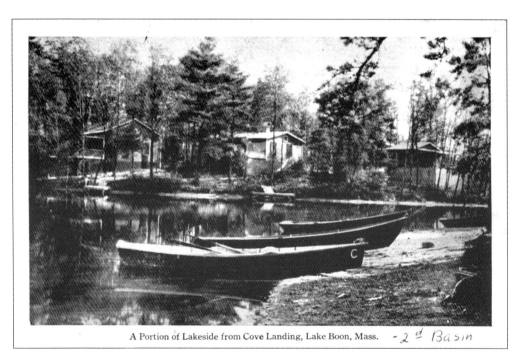

Shown here is a portion of the Lakeside section of Lake Boon as seen from Cove Landing. (Batsford.)

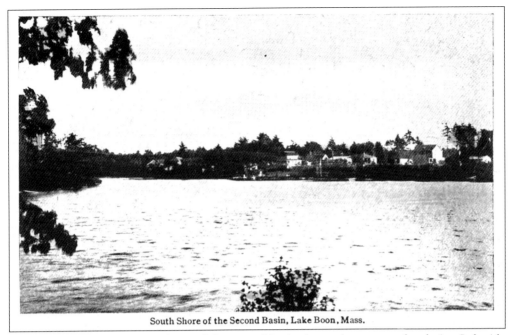

The wide view of the south shore of the second basin shows the cottages bordering Lakeside Avenue. (Phalan.)

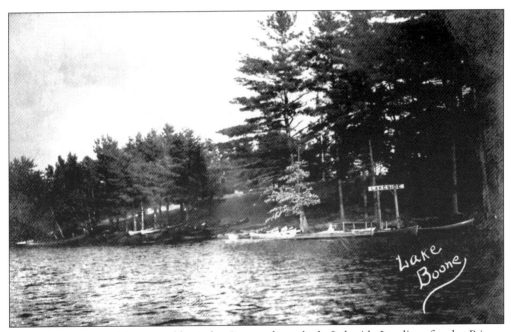

The Lakeside area of the second basin has its own boat dock, Lakeside Landing, for the *Princess* to pick up and drop off passengers. (Boothroyd.)

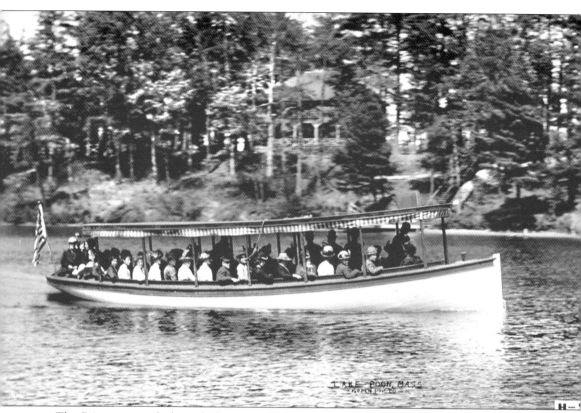
The *Princess* proceeds through the second basin on its traversing route of Lake Boon. (Halprin.)

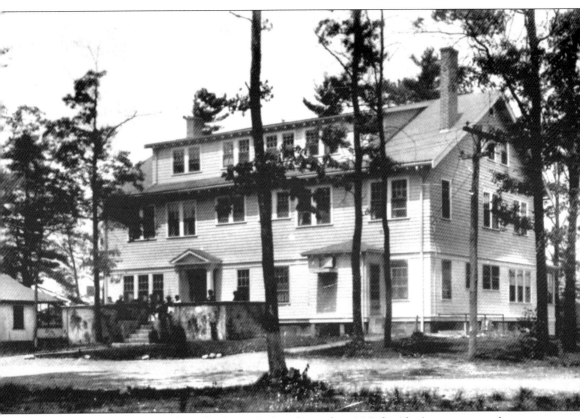

Completed in May 1923, the Lake Boon Lodge, located at 46 Lakeside Avenue, proved very popular and was almost always full during the summer months. Unfortunately, it caught fire one January night in 1927, and despite the fire department's best efforts, it burned to the ground. The hotel has since been replaced by a private residence. The little cottage shown at the left of the picture is still standing. (Conard.)

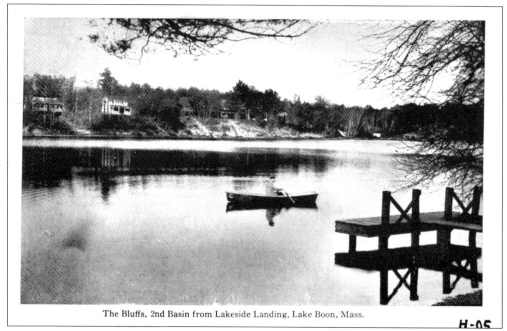

The Bluffs, 2nd Basin from Lakeside Landing, Lake Boon, Mass.

From Lakeside Landing on Lakeside Avenue, a steep-banked section on the north side of the second basin can be seen. (Halprin.)

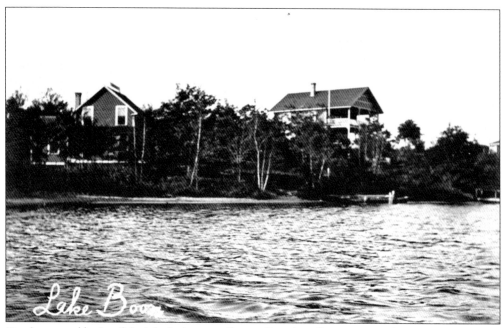

On the second basin of the lake is the proudly standing Arcadia cottage with its distinctive two-story porch overlooking the lake. (Phalan.)

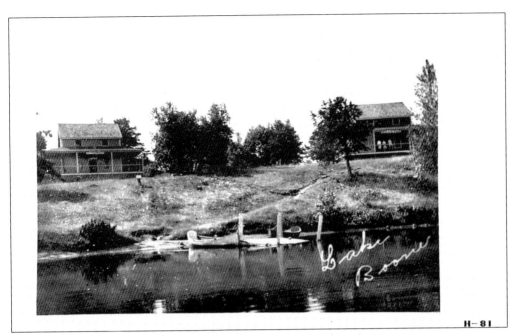

Bellevue cottage (right) shares a dock with its neighbor. (Halprin.)

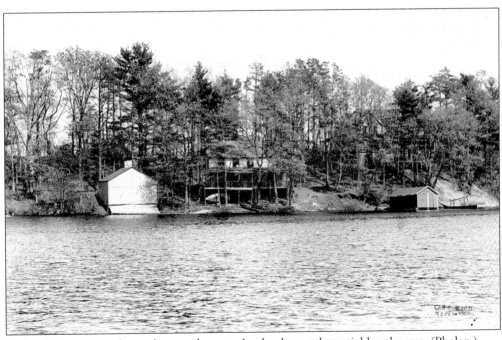

Both of the cottages shown here at the water's edge have substantial boathouses. (Phalan.)

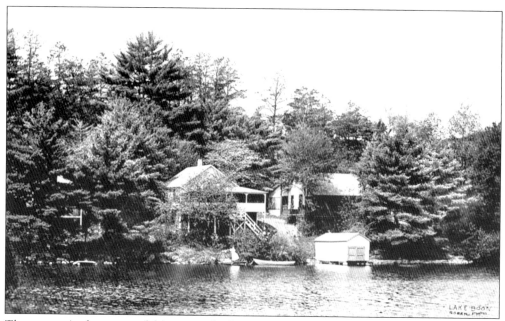

The cottage in the center of this postcard, Pleasant View, has the lady of the house getting ready to enter her boat for a trip on the lake. (Boothroyd.)

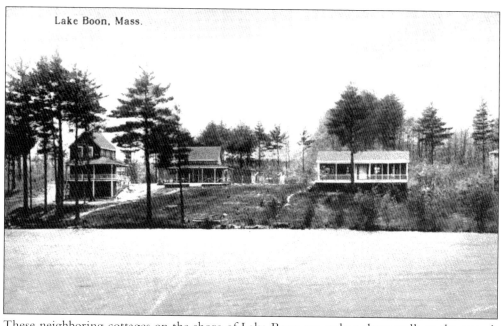

These neighboring cottages on the shore of Lake Boon are only a short walk to the water's edge. (Boothroyd.)

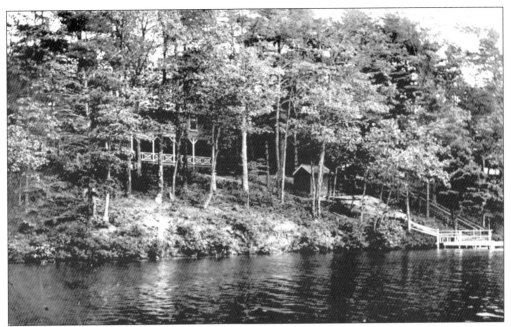
The owners of this cottage have a long trek down to their dock. (Phalan.)

Part of the third basin of Lake Boon is fairly shallow, but very beautiful. It has lots of little forested inlets that are difficult for motorized boats to navigate. (Boothroyd.)

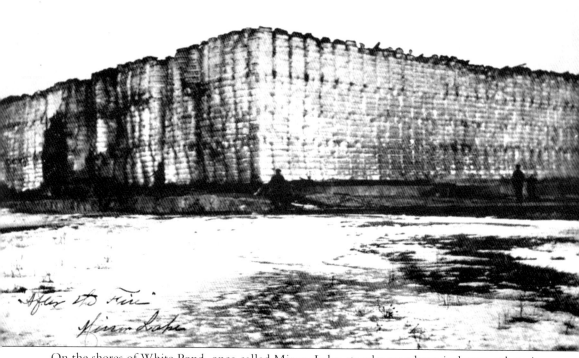

On the shores of White Pond, once called Mirror Lake, stood a very large icehouse, where ice from White Pond was cut, harvested, and stored during the winter. The icehouse had four floors and motorized conveyor belts to hall the ice blocks up and down. In the summer, the ice was sent by railroad to all parts of New England. Around 1924, the icehouse burned down, possibly by sparks from a steam locomotive on the nearby railroad. All the wood and hay that was used for insulation burned to the ground leaving only this large block of ice to slowly melt during the summer. (Kattelle.)

Six
The Bluffs

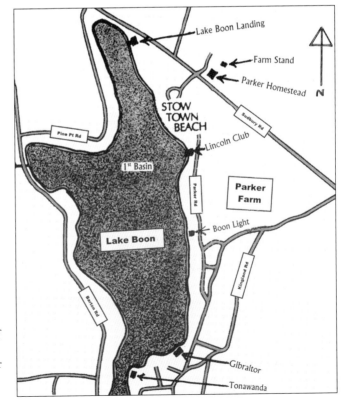

The east side of the first basin is dominated by a bluff resulting in a lower density of cottages. Yet the first recreational cottage, the Lincoln Club, was situated here where the Stow Town Beach is now located. Most of this section of the lake was at one time owned by the Parker family whose farm occupied most of the area. (Halprin.)

Some photographers had special cameras that allowed them to create a very wide panorama view of an area. Several such photographs were made of the Lake Boon area. The series shown here was taken around 1900 from Honey Pot Hill. The panorama photograph was converted to a set of four postcards that, when put together from left to right, provide a good view of Lake Boon and its environment, especially the bluffs area. The above picture is the first panel of a four panel postcard series. (Parker family.)

This postcard is the second panel of a four-panel postcard series that shows the view from Honey Pot Hill around 1900. (Parker family.)

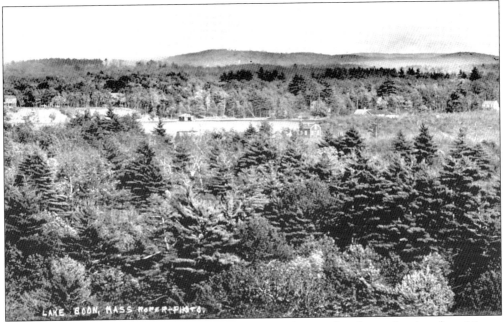

This postcard is the third panel of a four-panel postcard series that shows the view from Honey Pot Hill around 1900. (Parker family.)

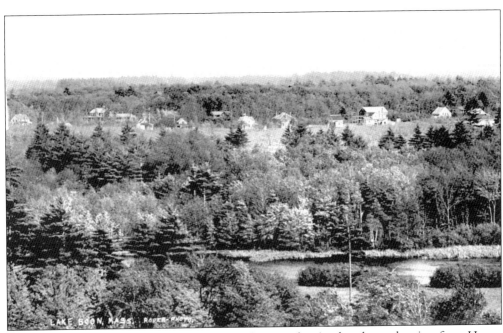

This postcard is the fourth panel of a four-panel postcard series that shows the view from Honey Pot Hill around 1900. (Parker family.)

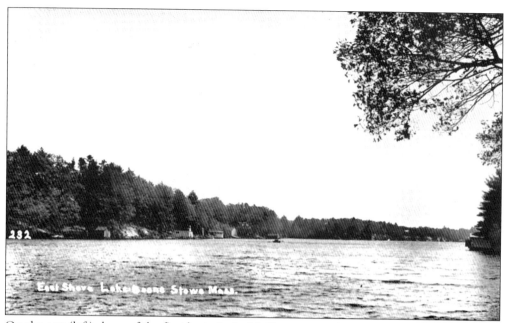

On the east (left) shore of the first basin is the bluffs area containing many cottages, including that of Boon Light, whose miniature lighthouse can be seen just to the left of center in this postcard. (Phalan.)

Boon Light cottage, owned by the Gleason family of nearby Gleasondale, features not one but two miniature lighthouses. (Halprin.)

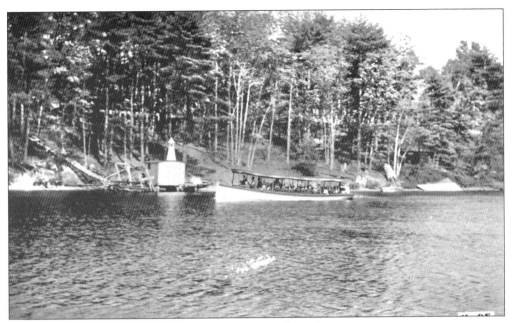

The *Princess* makes a stop at Boon Light cottage. (Halprin.)

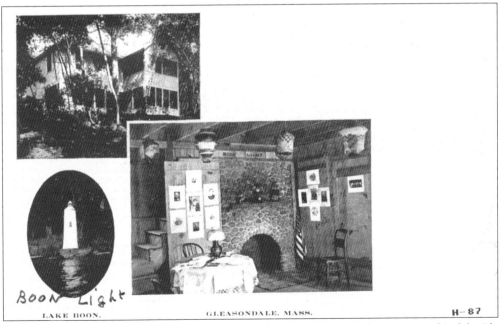

This postcard is a composite view of the outside and inside of Boon Light cottage and its lakeside miniature lighthouse. Although the postcard says Gleasondale, Boon Light was actually in Stow on Lake Boon. (Halprin.)

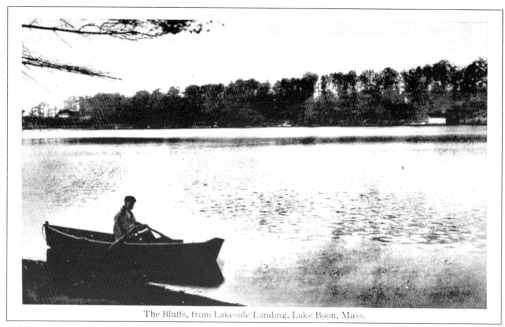

A lone oarsman takes his boat from the Lakeside Landing dock into the waters of Lake Boon's second basin. (HHS.)

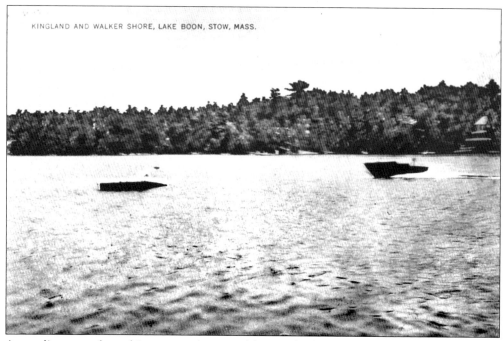

A speeding motorboat skims across the second basin of Lake Boon with the Kingland area of the bluffs visible in the background. (Parker family.)

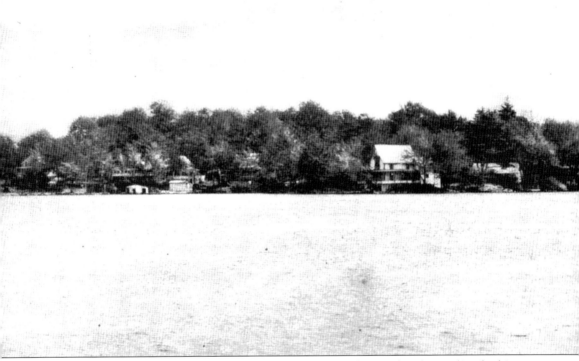

This postcard, which shows a quiet lake, was probably taken from Lakeside Landing looking across the second basin toward the bluffs. (Parker family.)

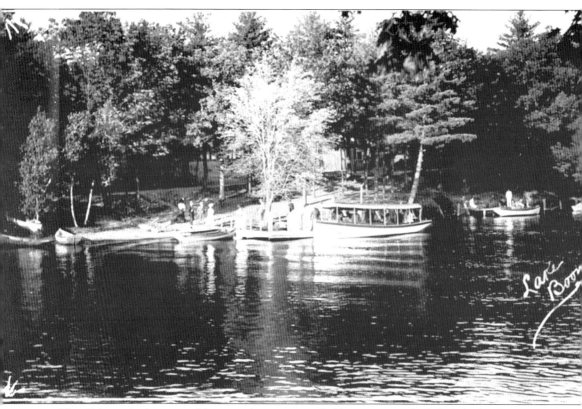

The *Princess* is shown making another stop, probably at an unscheduled dock where some passengers waved down the boat. (MHS.)

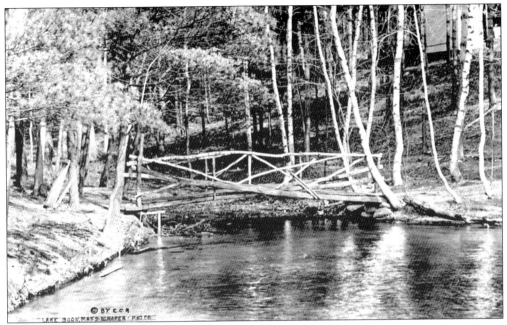

This bridge spans what used to be an old road before it was flooded by the Lake Boon dam. Now it serves the Satawissa cottage located on the east side of the first basin. (Top Batsford, bottom HHS.)

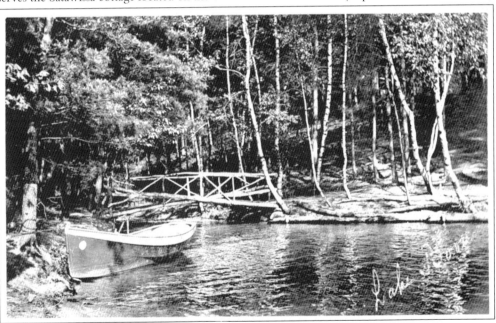

One of the first cottages built on the lake was the Lincoln Club, located in a little sandy cove in the middle of the bluffs. The cottage, a corner of which is showing in the bottom left of this postcard, was built so that part of it extended out over the lake. The Lincoln Club was situated at the current location of the Stow Town Beach. (Halprin.)

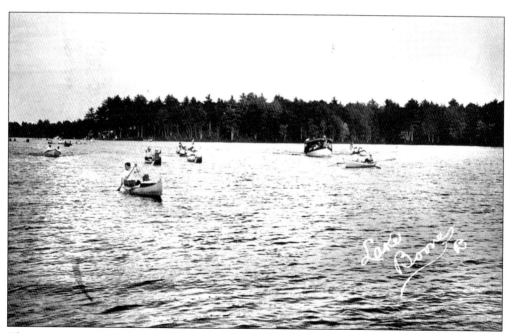

The *Princess* is joined by a handful of canoes and other small boats as it approaches Bluff's Landing. (Phalan.)

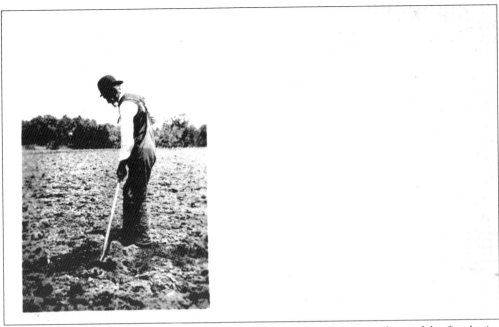

At the end of Davis Road is Parker Road, which follows the whole east shore of the first basin. All this land used to be owned by the James Parker family and was a large farm. When the lake became a recreational area, James quickly realized the extra money he could make by building cottages along the lake's shore and renting them to summer people. (Parker family.)

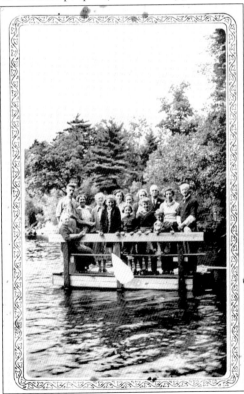

The entire Parker family gathers on their dock for a family reunion photograph. (Parker family.)

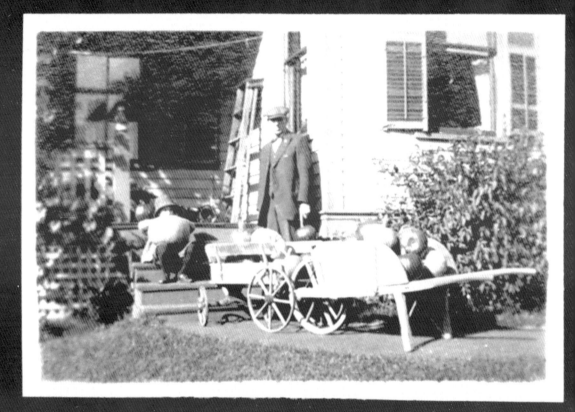

THE FIRST LOAD—150 IN ALL

A man brings in pumpkins from a field to sell at the Parker farm stand. The Parker farm stand was located just behind the Parker family's elegant home situated on Sudbury Road overlooking the fields on top of the bluffs. These fields were used to grow many different kinds of farm products, most of which were available to the summer Lake dwellers around the lake. The store was a popular destination to pick up fresh farm produce, such as corn, to be eaten the same day it was picked. (Parker family.)

This is a typical cabin on the Parker farm on Parker Road. Many of these cabins were built by the Parker's to rent out during the summer, providing extra income. (Parker family.)

Looking inside a typical Lake Boon cottage shows a kitchen with large swing-up windows that connect the cottage dwellers to the woods and lake outdoors. (Parker family.)

A view of thin woods, mostly pine trees, surrounds the lake. (HHS.)

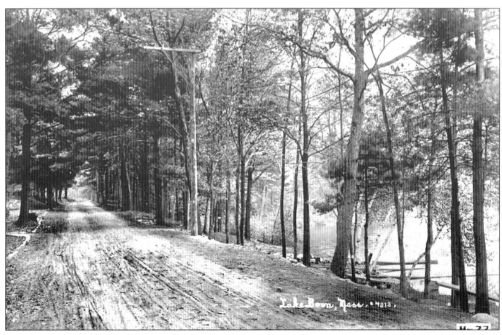
Pictured here is the highly traveled Sudbury Road by Lake Boon Landing. (Halprin.)

Seven
Summer Recreation

Some boys fish off a dock at the point where Lake Boon expands from the narrows into the second basin. (HHS.)

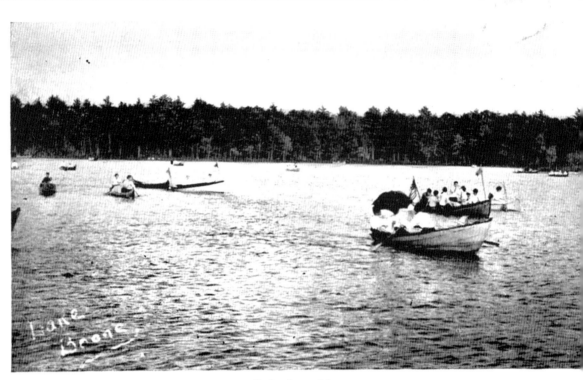

Lake Boon, Mass

On a bright and sunny summer day, many of the boats on the lake come out to parade around and meet their neighbors. (HHS.)

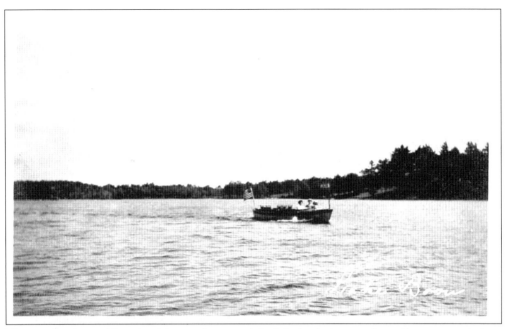

The couple pictured here is taking a spin around the lake in their motorboat. Current regulations limit motorboats to no-wake speed on Sundays and holiday afternoons to provide a more peaceful lake for slower craft and swimmers. (Phalan.)

A single rower has the lake all to himself. (Phalan.)

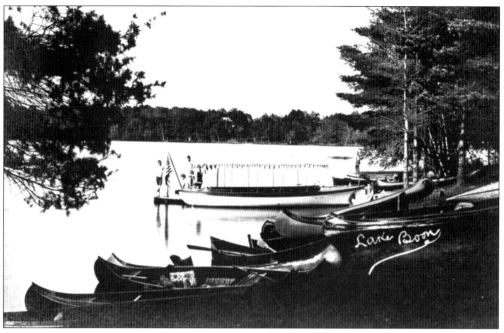
This popular spot on the lake, possibly Canning's Point, is visited by many people using their canoes, which are casually beached. (Phalan.)

Two canoeists enjoy the shoreline of the lake. (Phalan.)

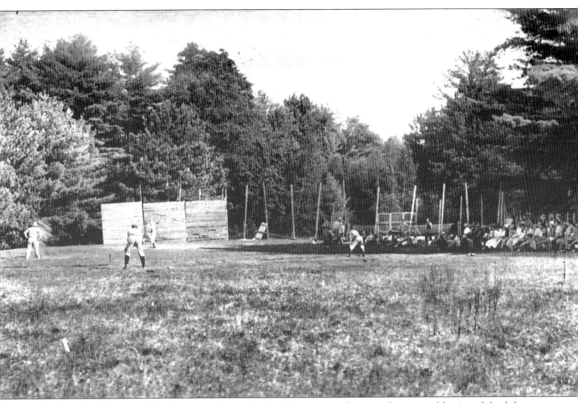
This baseball diamond, believed to be on Lakeside Avenue close to the second basin of the lake, attracted a good number of lake residents to view the games. It is also believed that there was another ball field at Canning's Grove. (Case.)

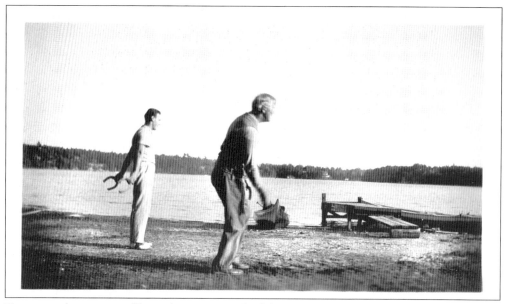

Two men play a game of horseshoes next to the lake. It was not unusual for cottages to set up a horseshoe pitch. (Case.)

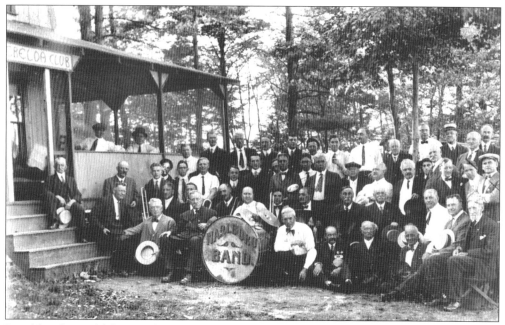

Local bands would frequently come to the lake during the summer to play marches. In this postcard, the Marlborough band takes a break during an afternoon concert. (Conard.)

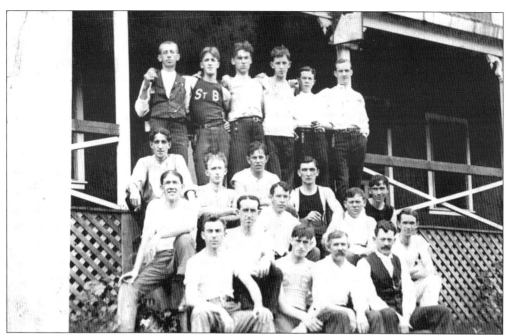

Members of the Twilight Club are sitting on the front porch of their club cottage located in the narrows section of the lake. The Twilight Club was one of the many bachelor clubs around the lake. Other such clubs included Tonawanda, Wisteria, Parks, Lone Pine, Sea Gull, Lincoln, and Fairview. (MHS.)

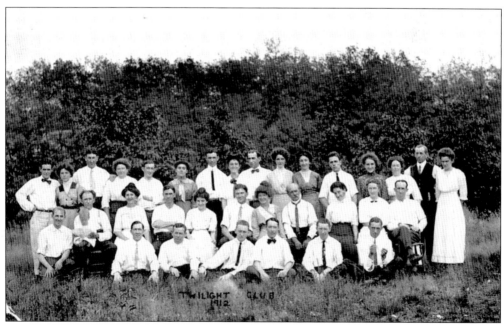

Members and guests of the Twilight Club pose on the lawn. During such gatherings women wore long dresses, and most men wore white shirts and ties. (Boothroyd.)

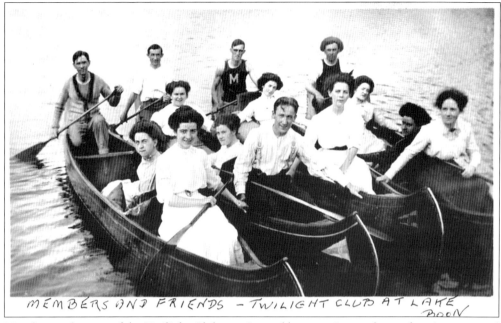
Members and guests of the Twilight Club are pictured here getting ready to take a jaunt around the lake in canoes. (Boothroyd.)

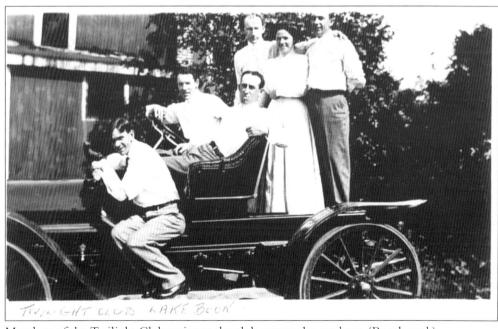
Members of the Twilight Club arrive at the club cottage by roadster. (Boothroyd.)

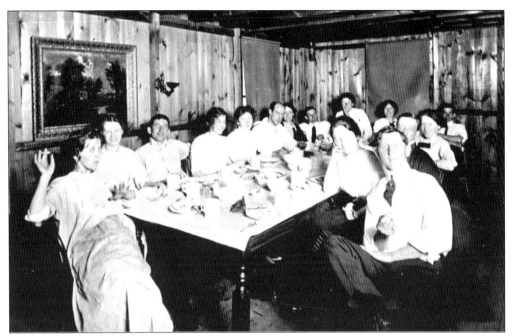

Twilight Club members and their guests are pictured here enjoying a formal dinner in the comfort of their club cottage's large club room. (MHS.)

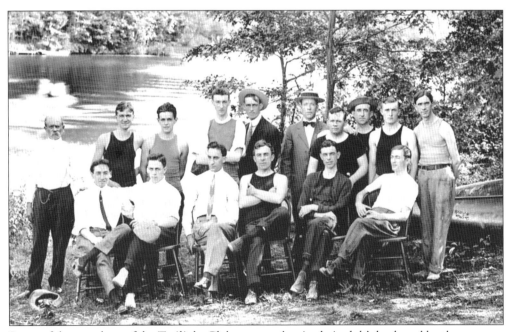

Some of the members of the Twilight Club get together in their club's backyard by the narrows of Lake Boon for a group photograph. (MHS.)

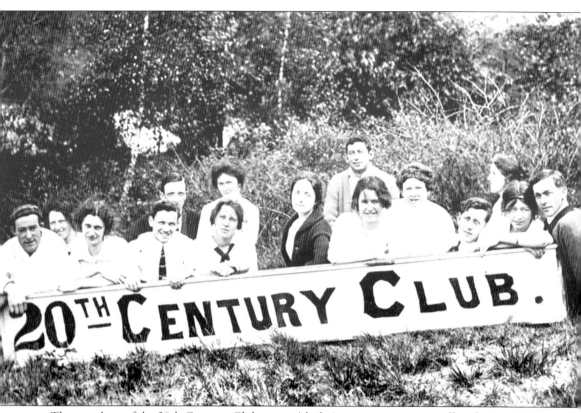
The members of the 20th Century Club pose with their women guests as well as their new sign that will soon be hanging over the entrance to the club cottage. (Boothroyd.)

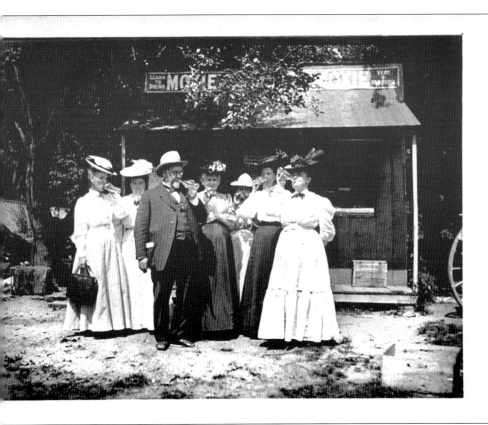

This refreshment stand, possibly located at Canning's Picnic Grove, featured Moxie, a special New England soda that some people liked, but many found foul tasting. Notice that only one person seems to be holding their bottle of Moxie high enough to be actually drinking the stuff. (Parker family.)

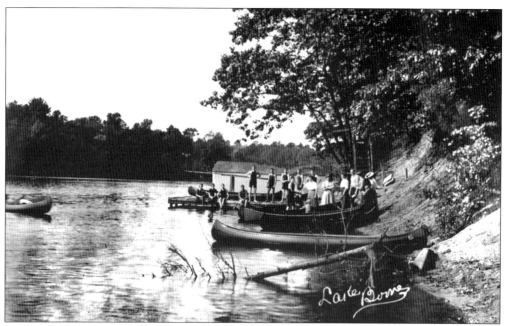
A group of young adults prepare to go canoeing and swimming. (MHS.)

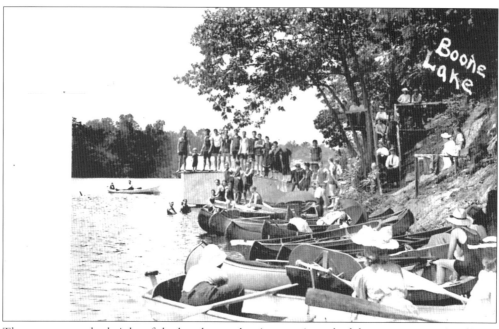
The group uses the height of the boathouse that juts out into the lake as a community diving board. The slope of the hill to the right is an indication that the water at this spot becomes deep very quickly, thereby providing a depth at the end of the boathouse to safely dive. (Batsford.)

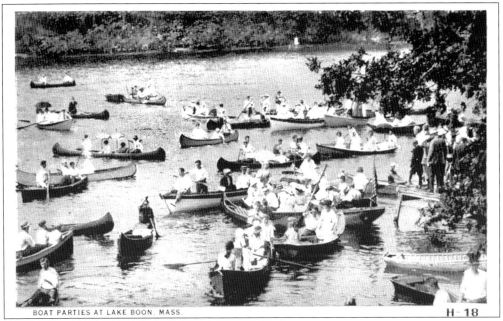

The Lake Boon Association organized many activities for lake residents during the summer. Many of these activities were athletic contests, but others were intended to get the lake community to share in some party activity. The people in these canoes are probably gathered together for a 4th of July party to hear a speech or speeches given from the dock (right). The canoes are filled with women wearing fancy full-length dresses and men wearing white shirts. (Halprin.)

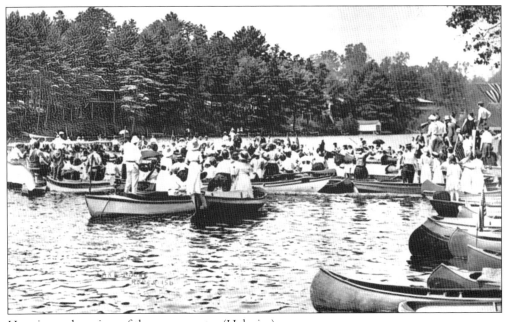

Here is another view of the canoe party. (Halprin.)

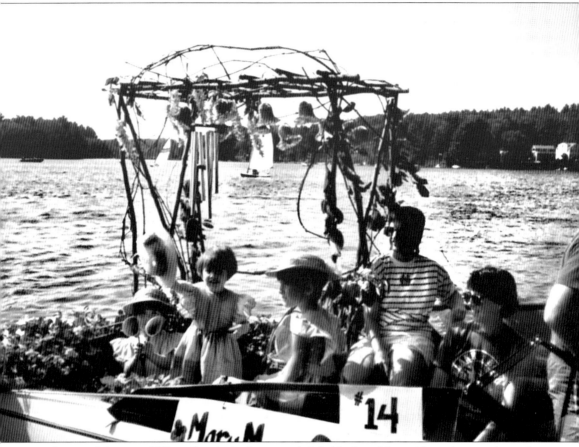

As part of the annual Water Carnival, a boat parade is held where lake residents dress up themselves and their boats, and form a parade around the lake to compete for prizes and awards. Over the many years that this boat parade has taken place, boat decorations from simple to very elaborate have been entered, including a very detailed four-smokestack Titanic, a World War II aircraft carrier, a side-wheel river boat, and even a replica of the *Princess* boat that used to carry passengers around to their docks on Lake Boon. (Parker family.)

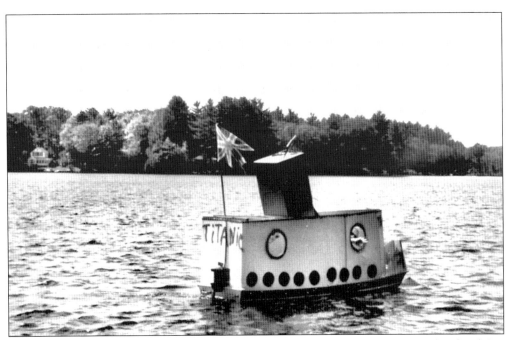

This boat, from the boat parade in August 1992, is decorated as a mini *Titanic*. (Parker family.)

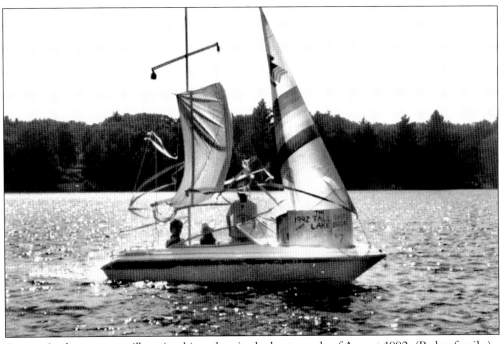

A motorized two-mast sailboat is taking place in the boat parade of August 1992. (Parker family.)

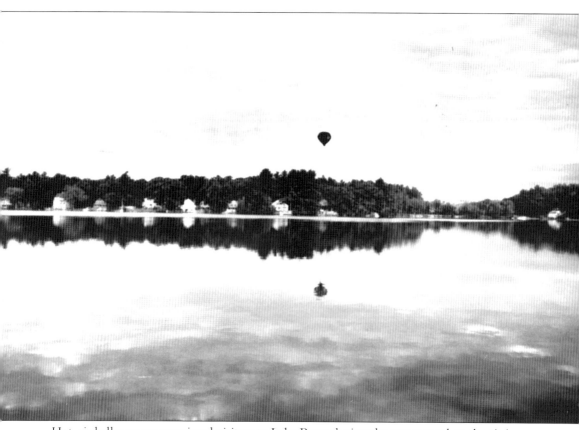
Hot-air balloons are occasional visitors to Lake Boon during the summer when the air is warm and the wind is light, usually in the early morning or around dusk. The lake is a favorite target for these balloons where they sometimes come down and just barely touch the lake, then lift off again to continue their journey. (Halprin.)

Eight
Winter Recreation

Although most Lake Boon residents live there full-time now, this was not always the case. In the first half of the 1900s, many Lake Boon residents lived there only in the summer and would occasionally visit in the winter to enjoy sports such as ice fishing, ice sailing, or ice hockey. However, a handful of people stayed all winter long in cottages and homes that were winterized. There was a thriving business of cutting ice from the lake and storing it in insulated ice houses to sell to the summer residents for their iceboxes. (Halprin.)

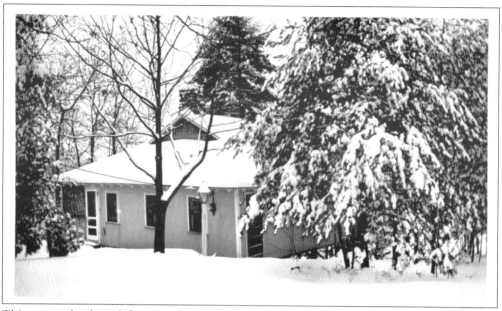
This cottage has been left empty during the winter. (Parker family.)

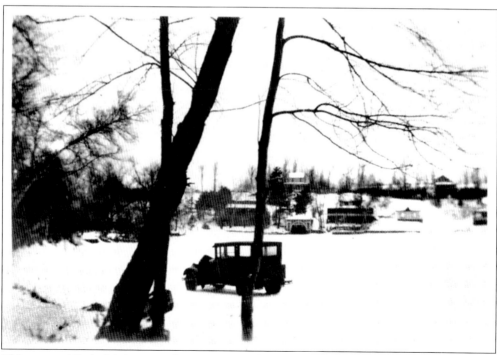
This automobile is driving over frozen ice near the dam, possibly going out to check their ice fishing sets for success. (Case.)

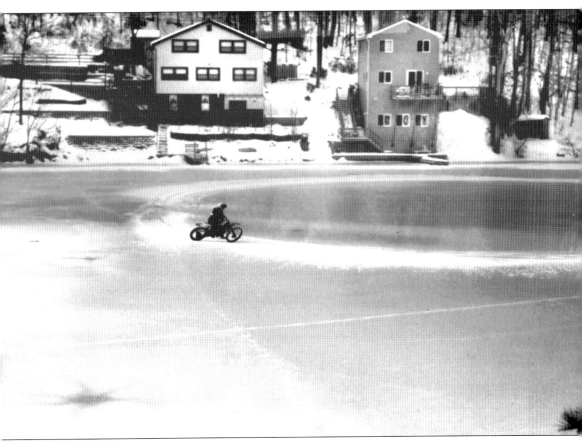

The rider of this motorcycle is taking the chance that the ice is thick enough for him to ride over. (Farrell family.)

This view shows Sudbury Road as it circles around the base of the northern end of Boon Hill

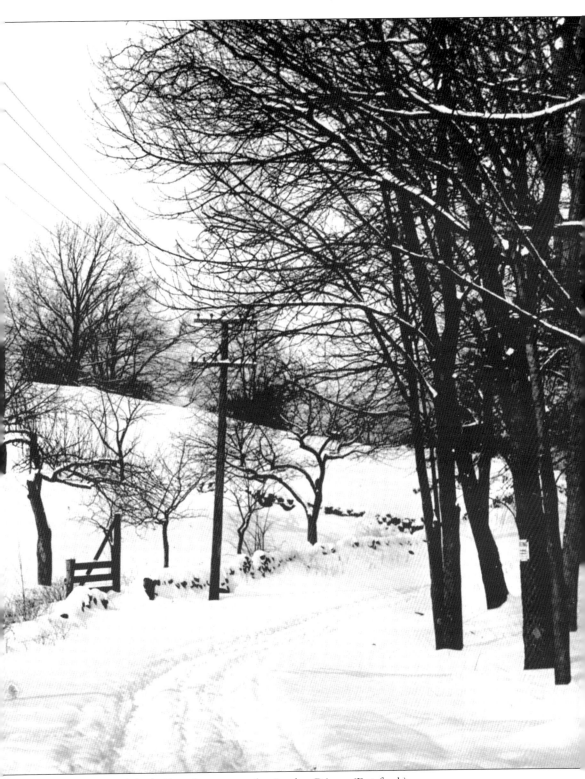
and heads toward the bridge that crosses the Assabet River. (Batsford.)

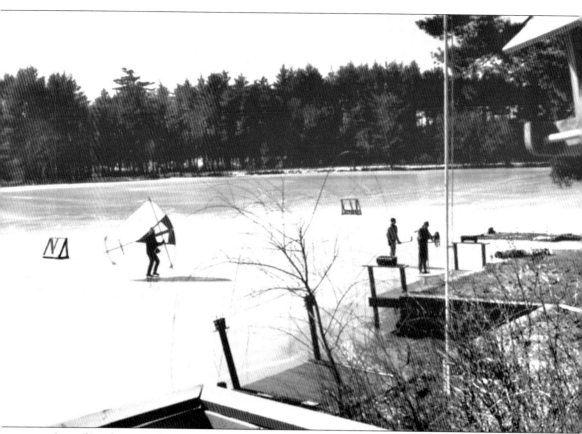

Ice sailing does not always require elaborate contraptions. The person in this picture is ice sailing by wearing a pair of ice skates and holding onto the sail from a sailboat used in the summer. In the background, goals are seen for a hockey game about to begin. (Halprin.)

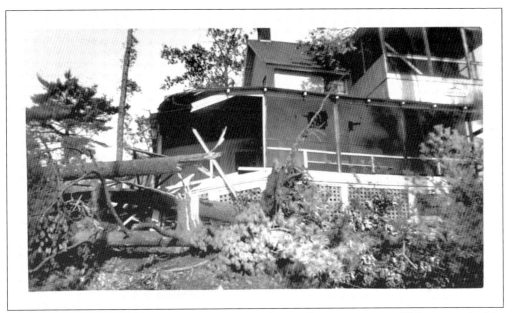

The 1938 hurricane that passed over Lake Boon damaged many cottages. This cottage had its porch roof destroyed. (Parker family.)

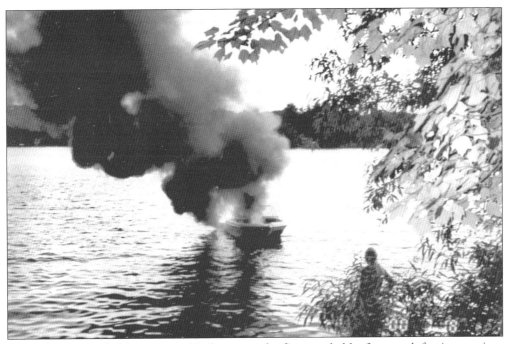

Though surrounded by water, this boat caught fire, probably from a defective engine. (Parker family.)

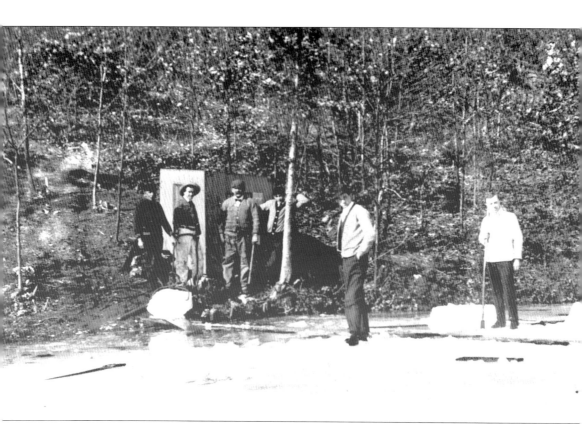

Members of the Maynard Twilight Club on Barton Road cut some ice from the lake in front of their clubhouse to be stored for use during the summer. The ice was cut, often using special ice-cutting saws into blocks not too heavy to lift and carry, and stored in specially built ice-sheds that were built with double walls and ceilings with the space between them filled with sawdust or hay to provide insulation from the summer heat. Ice so stored could last through most of the summer when it would be used to place in iceboxes that kept food cold before the days of refrigerators. There were several of these ice-storages sheds around the lake, at least three of them for commercial purposes. (Conard.)

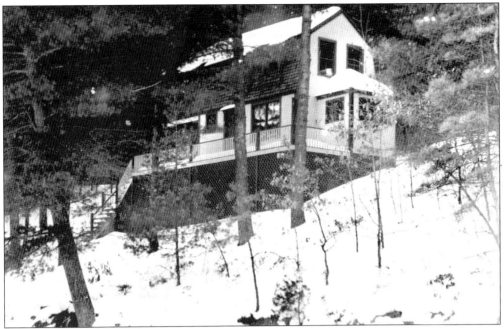

This cottage on Pine Point Road is located on the slope of Boon Hill. (Conard.)

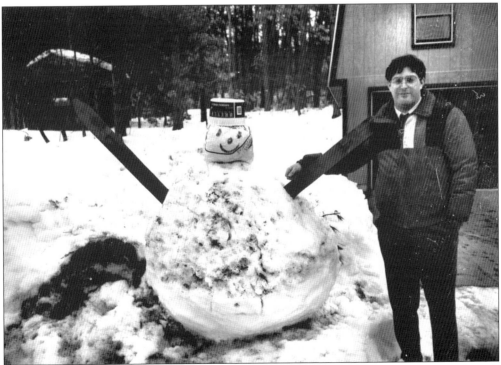

Building snowmen is a popular activity for Lake Boon residents during the winter. (Halprin.)

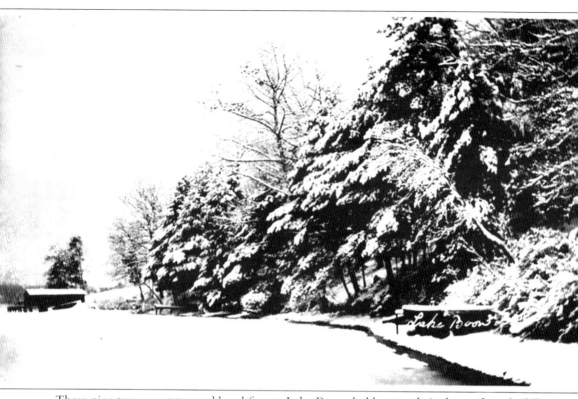

These pine trees, next to a cold and frozen Lake Boon, hold on to their share of newly fallen snow. (Halprin.)

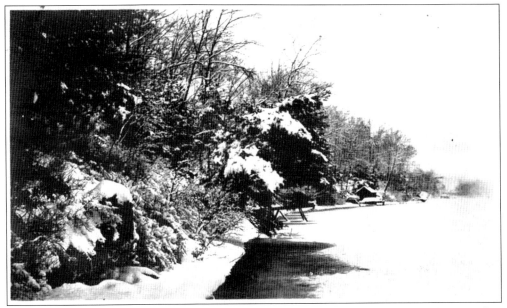

The snow lightly covers the ice, shore, and trees of the lake on this bright and sunny day. (Parker family.)

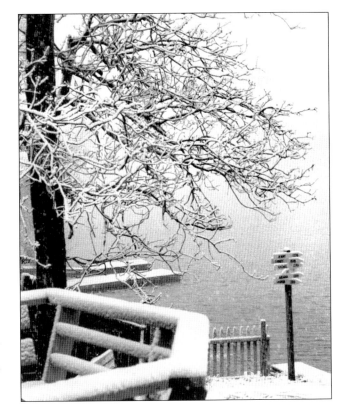

The snow has just begun to fall in what will be a very heavy snowstorm. It's still early in the winter and the lake has not yet frozen. (Halprin.)

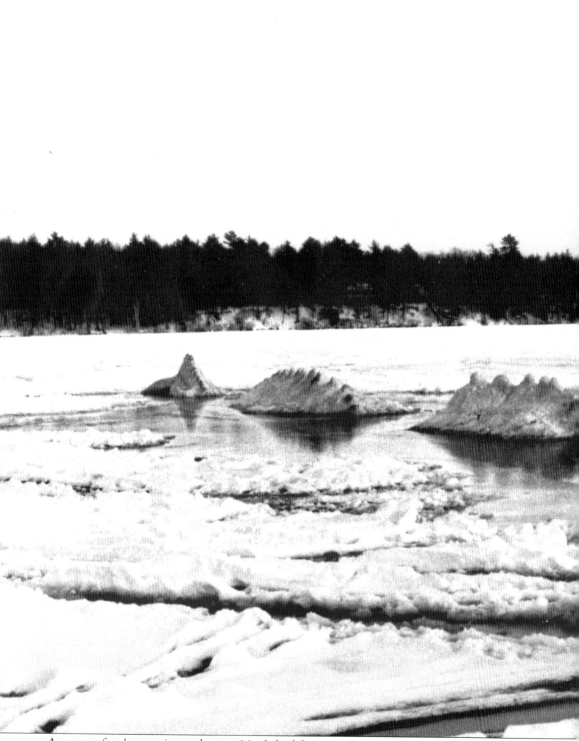

A group of unknown ice sculptors visited the lake one winter to construct this dragon out of snow and ice from the lake. The sculpture was made around the dam outlet providing those

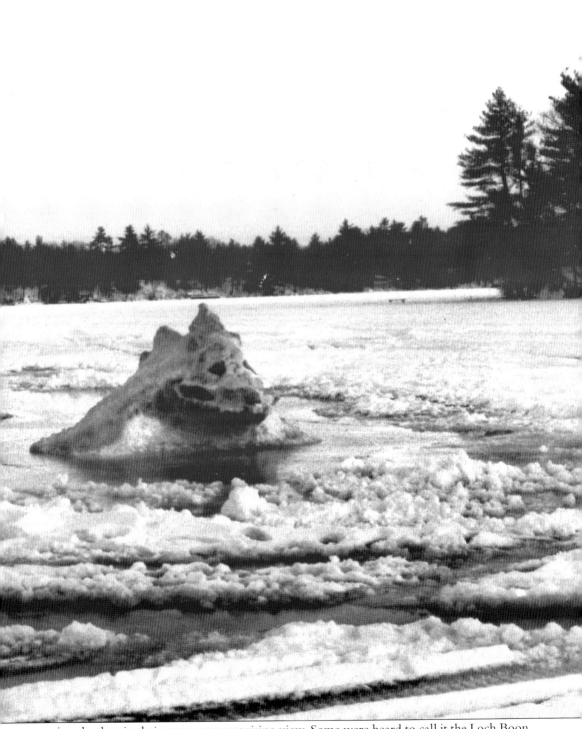
crossing the dam in their cars a very surprising view. Some were heard to call it the Loch Boon monster. (Halprin.)

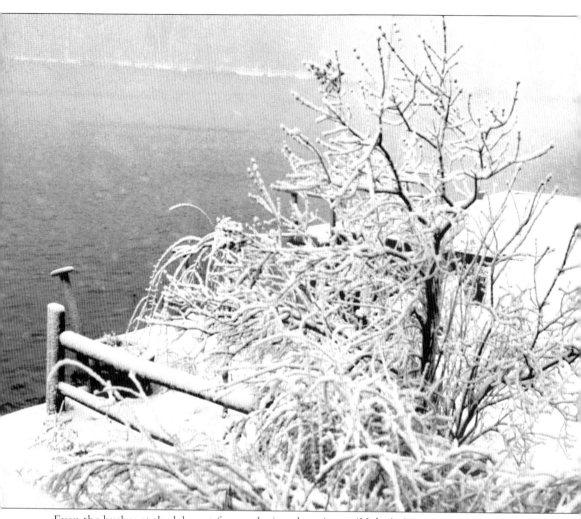
Even the bushes at the lake get frozen during the winter. (Halprin.)